Roman Pottery

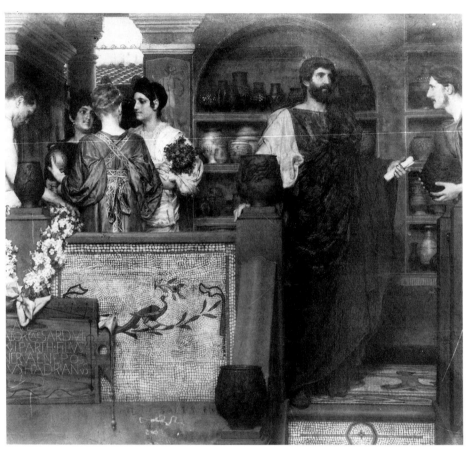

Painting by Sir Lawrence Alma-Tadema depicting a visit by the emperor Hadrian to a Romano-British pottery. The artist included accurate representations of real Roman pots, many of which are now in the British Museum. We know that Hadrian did visit Britain, but Alma-Tadema's notion that a Roman emperor would concern himself with arts and crafts is a very nineteenth-century concept. However, it does reflect the growing interest in 'ordinary' artefacts which led to the serious study of pottery by archaeologists.

INTERPRETING·THE·PAST

ROMAN POTTERY

Kevin Greene

Published for the Trustees of the British Museum
by British Museum Press

Acknowledgements

I am very grateful to the individuals and institutions listed below who supplied me with illustrations, and also to several others who sent material not included because of limitations on space. Special thanks go to Catherine Johns and Val Rigby, who helped to improve this book in many ways. I could not have written it without the supportive atmosphere and facilities of the Department of Archaeology in the University of Newcastle, and constant help from its librarian, Pat Southern. My wife and family allowed me to neglect domestic responsibilities in order to spend many undisturbed hours on proofreading and indexing. Finally, sincere thanks must go to Nina Shandloff at British Museum Press for hounding me relentlessly (in the nicest possible manner) at every stage after persuading me to follow an accelerated production schedule! Her efficiency has allowed the entire project to be completed in less than eighteen months.

T. Artis, *The Durobrivae of Antoninus*, 1828, pl. XL: 7; Trustees of the British Museum, London: 1 (PRB 127685), 13 (EA 1929. 10–16. 132; 1856. 12–26. 558; Vase L 50; GR 1972. 9–27. 1; GR 1920. 11–18. 25; GR 1814. 7–4. 676; MLA 1928. 4–13. 10), 15 (SR), 27 (PRB 1.87.94. 2–22. 1); Richard Carlton: 26; Corbridge Museum (photo Neil Askew): **cover**, 3, 21, 22, 30; J. Déchelette, *Les vases céramiques ornés de la Gaule romaine*, 1904, vol. I, fig. 126: 11; M. G. Fulford and D. P. S. Peacock, *The Avenue du President Habib Bourgiba, Salammbo*, 1984: **18**, **19**; photo Patrick Greene: 9; redrawn by Sandra Hooper: 4, 5 (from author's originals); 20 (from data in *Papers of the British School at Rome* 32, 1968, pp. 180–95); 2 (from G. C. Duncan's drawings in *Papers of the British School at Rome* 32, 1964, pp. 74ff); 12 (from J. P. Gillam, *Glasgow Archaeological Journal* 4, 1976); 28 (from K. Greene, *Archaeology of the Roman Economy*, 1986, p. 163); 8 (from B. Pferdehirt's maps in *Jarhbuch römisch-germansich Zentralmuseum* 33, 1986); 16 (from data in S. von Schurbein, *Die unverzierte terra sigillata aus Haltern*, 1982); Musée du Chateau, Blain: **10**; Musée Fenaille, Rodez, Collection Société des lettres de l'Aveyron: **25**; Museum of London: **14**; Museum für Vor- und Frühgeschichte, Frankfürt am Main (Drs I. Zetsche and P. Fasold): **6**; F. Reutti, *Neue archäologische Forschungen im römischen Rheinzabern*, 1991): **23**, **24**; Rheinisches Landesmuseum, Bonn: **29**; Stedelijk Museum, Amsterdam: **frontispiece**; Robin Symonds: **17**

Published by British Museum Press
a division of British Museum Publications Ltd
46 Bloomsbury Street, London WC1B 3QQ

Designed by Andrew Shoolbred

Set in Linotron Palatino and printed in
Great Britain by The Bath Press, Avon

ISBN 0–7141–2081–2

British Library Cataloguing in Publication Data
A catalogue record for this book is available
from the British Library.

Cover illustration Sherds of terra sigillata, fine and coarse wares from excavations at Corbridge Roman fort and town, Northumberland.

Contents

Preface

Its sheer abundance makes Roman pottery particularly useful as a means of understanding the society which created it. Fortunately for archaeologists, ceramic artefacts combine fragility with durability: they were easily broken, and the resulting fragments were simply thrown away. Unlike pieces of metal or glass, potsherds could not be melted down and reused. Once discarded and buried ceramics survive indefinitely, and generally require little more than washing after recovery from excavation.

In Roman times pottery was used for a wider range of purposes than in most periods of prehistory or the Middle Ages. Dolia and amphorae provided strong vessels for storage and transportation; many forms of jars and bowls served as efficient cooking pots. Fine plates, cups and beakers added a touch of elegance to dining tables even in quite modest households, and pottery oil lamps provided light. Many Roman buildings were constructed (wholly or partly) from bricks and roofed with ceramic tiles, while specialised clay elements aided the construction of bath-buildings and vaulted ceilings.

Non-specialists may be surprised by the contrast between museum displays of clean complete pots (frequently from graves) and the contents of a finds-tray at the side of an excavation trench. Most pottery is found in small fragments, and many of these are relatively unilluminating body-sherds. Bones frequently outnumber potsherds on sites where non-acidic soil conditions allow their survival, and most finds-trays also contain miscellaneous lumps of corroded iron and scraps of brick and tile. Everything has to be washed and sorted before a pottery specialist can begin to identify the significant rim shapes or decorated sherds that can give a rough idea of the date of the excavated deposit (this is the first question that is likely to be asked). Frequently the deposit will turn out to have been disturbed by later activities on the site and to contain vessels of widely differing dates, and thus be of limited value for interpreting the Roman pottery.

A more interesting group of sherds is sometimes recovered from a large closed deposit, such as a rubbish pit, along with independent dating evidence (ideally coins). A pottery specialist will immediately start to think about its interpretation: do the coins suggest that this pottery belongs to a period for which dating is uncertain, so that the group will form a useful reference point for other sites? Are there large unweathered sherds which fit together to make more or less complete pots, suggesting the disposal of breakages from an adjacent building? Or are there many small unrelated fragments which have been thrown into this pit after lying around elsewhere, perhaps for a long time? Are distinctive forms of vessels present which suggest particular functions, such as cooking or food storage? Does the group contain fine imported tablewares and wine amphorae which will reveal information about wealth and trade?

The study of pottery is not only an essential part of the investigation of sites by excavation, but also an important part of Roman 'industrial archaeology'. It reveals details of technology and methods of manufacture, and through careful analysis of patterns of production and distribution archaeologists can explore many broader aspects of the economy and society of the Roman world. This book looks at how such research has developed, how archaeologists study Roman pottery today, and how the range of conclusions they draw can help us to interpret the past. Because this short book only attempts an overview, a guide to further reading is given on pp. 62–3.

— 1 —

What is Roman Pottery?

Roman civilisation displayed two very distinctive features during the course of its expansion from city-state to empire over a period of around five hundred years. Able to absorb useful aspects of pre-existing cultures, it also spread a Romanised way of living (rather than mere political control) by inspiring emulation, rather than by force. Tacitus described this phenomenon in a typically cynical fashion as it took place in Britain in the first century AD:

> And so the Britons were gradually led on to the amenities that make vice agreeable – arcades, baths and sumptuous banquets. They spoke of such novelties as 'civilisation', when really they were only a feature of enslavement.

Roman power expanded slowly but surely from the fifth century BC, first in Italy, then around the Mediterranean, and finally outwards towards northern Europe. The empire reached its maximum extent in the second century AD, and then remained fairly stable until it disappeared entirely in the west in the fifth century. The east underwent gradual contraction and transformation to become the medieval Byzantine empire, but for a brief period in the sixth century, the emperor Justinian reconquered Italy and several of the former western provinces in Spain and North Africa.

Although the term 'Roman' can still be applied to ceramics used around the Mediterranean as late as the seventh century, it is more difficult to decide how to describe pottery of a much earlier date. Rome absorbed areas of Italy which already possessed well-established ceramic traditions – Celtic in the north around the Alps, Etruscan in central Italy and Greek in the south. By the time that the 'empire' began under Augustus (27 BC), Roman military power extended over Carthage, Spain, Greece and Egypt, and the culture, art and architecture of Italy had been heavily influenced by Greece and Asia. Archaeologists need to understand the general historical and cultural background, because ceramics often reveal parallel influences. In areas north of the Alps, the term 'Roman', when applied to ceramics, is often used to indicate new forms and wares introduced by trade or conquest – in contrast to 'native' pottery of local origin. The term is used in this book in its broadest possible descriptive sense, simply to mean pottery of Roman date.

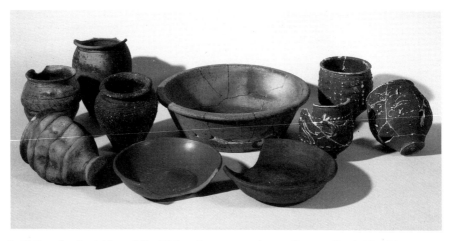

1 Pottery for the table and the kitchen from excavations at Stonea, Cambridgeshire: terra sigillata (*centre*), 'colour-coated' beakers with a dark slip (*right*) and plain earthenware vessels.

Finds from excavations show that Roman pottery provided a comprehensive range of vessels for table and kitchen functions, and for use in storage and transportation (fig. 1). At the top of the quality scale were vessels with a smooth glossy surface designed for the table: for example, the bright red *terra sigillata* mass-produced in Italy and elsewhere from the first century BC. Elaborately decorated cups and beakers with variously coloured surface coatings were used alongside this dinner service. However, the overwhelming majority of Roman pots were plain earthenware vessels designed for everyday household cooking and storage functions (fig. 2). The only really specialised forms were *amphorae*, used for transporting wine and oil, globular *dolia*, employed on farms for storage and fermentation, and *mortaria*, large bowls suitable for grinding and mixing the elaborate combinations of ingredients known to us from surviving Roman recipes (fig. 3).

Many archaeologists have studied the technology and distribution of specific forms of Roman pottery in Italy and the provinces. Their research reveals that production ranged from a part-time activity which supplemented farming to full-time employment for specialised craft workers. Most Roman vessels were formed on a potter's wheel and fired in carefully constructed kilns, although some surprisingly widely distributed kitchen wares were handmade and fired in bonfires. Some industries made wide ranges of forms, others concentrated on particular categories. Most Roman pottery seems to have been traded, rather than manufactured for the exclusive consumption of individual households or estates. Distribution patterns of wares varied enormously; Italian terra sigillata could be found throughout the empire, whereas unspecialised kitchen wares might only supply a single town and its surrounding region.

Roman pottery in Italy

The development of pottery studies, outlined in chapter 2, shows how the publication of modern stratigraphic excavations has only recently begun to reveal the full range of pottery – including ordinary kitchen wares as well as tableware and amphorae – that was used in Italy before the great expansion of the empire in the

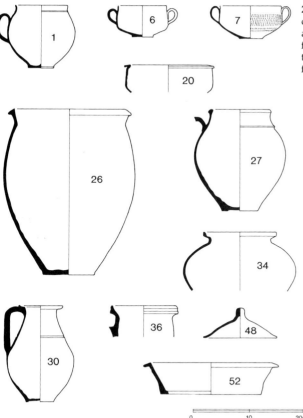

2 Some coarse ware forms of the mid-first century AD manufactured in central Italy on a kiln site excavated at Sutri. Many of the forms are closely related to vessels made in the provinces by the Roman army (see fig. 4).

first century BC. This knowledge is very important, for the spread of 'Roman' pottery into the provinces and its interaction with native products are a source of interesting cultural and economic information. An outline of the major kinds of pottery used in Italy around the end of the first century BC will help to explain the background of developments which took place in later centuries; technical aspects of the manufacture of these wares are explored in chapter 6.

Fine wares

Among the influences which reached Italy from Greece and Asia was the technique of coating tablewares with a *slip* (a thin layer of fine clay particles) which could be fired to a glossy black or red finish. This had been a standard feature of the famous Greek vases with painted red and black figural scenes since the sixth century BC. Their plainer counterparts were used as tableware and were widely imitated; this pottery is known as Campanian ware, after one production area in southern Italy. A trend towards red tablewares around the eastern Mediterranean was followed in Italy in the first century BC, and resulted in the familiar red 'Arretine' terra sigillata made on an enormous scale at Arezzo, Pisa, Puteoli and many other Italian centres. We know from the study of potters' names stamped on to vessels and from scientific analysis of clay fabrics that these centres exported high-quality pottery all over the empire (and beyond) at the end of the first century BC. Excavations on the kiln sites, together with finds on sites where the products were used, show that the principal forms mass-produced in terra

sigillata included cups and small bowls suitable for drinking or serving sauces, and plates of various sizes. The potters' repertoire also included elegant bowls with moulded decoration including figural scenes of excellent artistic quality; like Greek pottery, terra sigillata frequently imitated the form and decoration of more expensive metal tableware.

Another feature of pottery from Greece and Asia Minor was the production of drinking vessels with a coloured slip or a vitreous lead glaze, decorated by hand or in a mould. Slips and glazes became the normal surface finish for fine drinking vessels throughout the Roman empire, while moulding remained in use in tableware industries down to the late Roman period. Italian fine wares also incorporated plain 'thin-walled' drinking vessels, without a coloured slip.

Domestic pottery

Finds from excavations show that a moderately well-to-do Italian household at the time of Augustus (27 BC–AD 14) would have owned a terra sigillata dinner service, fine cups and beakers, and other vessels of glass and metal. The only plain earthenware pottery likely to be found at the table, rather than in the kitchen, would be elegant jugs or flagons. We know less about ordinary domestic pottery than about fine wares, but some informative stratigraphic sequences have been published from excavations, for example at Cosa, a colony founded on the west coast of Italy in 273 BC. It is clear that a recurrent and fairly consistent range of pottery types was required for food preparation, cooking, serving and storage purposes in ordinary Roman households (fig. 2).

Cooking pots were made of plain unglazed earthenware, and the large number of sherds found on sites suggests that they were broken and disposed of frequently. The commonest type was a tall round-shouldered jar with a constricted neck and out-turned rim, which could be fitted with a lid if required, for cooking or storage. Two further jar forms found in Italy appear more suitable for storage than cooking. One is a round-bodied vessel with an out-turned rim and two large loop handles on the shoulder, sometimes described as a honey pot; the second has an even larger ovoid body and a thickened rim with a wide, often horizontal, upper surface. Both forms could easily be fitted with simple conical lids, which are also common site-finds.

Almost as important as jars were large bowls with wide horizontal rims, vertical walls, and round-bottomed bases which would have given effective stability when placed directly on to a fire; again, a lid could be fitted. Shallower flat-bottomed bowls or platters were also available for baking or frying, and some even had a thick internal non-stick surface coating of fine clay. Some bowls were particularly suitable for holding and perhaps also serving liquids, for they have handles, or a projecting rim or flange, to facilitate lifting. The most distinctive bowl form was the *mortarium*, a robust thick-walled vessel with a heavy flange suitable for gripping and a wide flat base for stability. Grooves or large grits on the internal surface allowed herbs or spices to be ground up; vegetables could be liquidised and blended with other ingredients before being poured out by means of a spout on the rim (fig. 3).

There is no doubt about the function of flagons, which were ideal for storing and serving moderate quantities of liquids in the kitchen or at the table. Most have a spherical body and narrow cylindrical neck, with a distinct rim and a single handle; less commonly, the neck is wider and has two handles. Other flagons are more elegant, with rims and handles that imitate ornate bronze jugs.

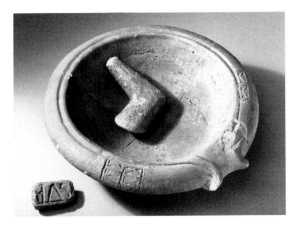

3 Mixing-bowl (mortarium) and stone pestle from Corbridge, Northumberland. Stamps on the rim either side of the spout indicate that this vessel was made locally in the workshop of Cudrenus. An actual stamp from the workshop of Saturninus (*lower left*) provides further evidence for local manufacture. Examples found in dated contexts on excavated sites indicate that these potters were active in the second century AD.

Flagons were frequently made from white clay, or at least coated with white slip, to improve their appearance for table use.

When it is possible to observe pottery from a sequence of dated deposits on a single site, it becomes obvious that changes took place which may reflect developments in food supplies and cooking methods. For example, ovoid pots of Iron Age origin, popular during the Republican period at Cosa, were replaced by open bowls in imperial times. Detailed studies of other excavated groups and kiln sites will eventually allow us to perceive other chronological and regional variations which must have resulted from the different histories and cultural backgrounds of southern, central and northern Italy.

Amphorae
Perhaps the most impressive pottery vessel adopted in Italy was the *amphora*, a large-capacity vessel with two handles and a pointed base. Finds from excavated sites and shipwrecks show that this form originally developed on the east Mediterranean coast in the fifteenth century BC, for the bulk transport of liquids (notably wine and oil). Phoenician trade and colonisation brought amphorae to the west Mediterranean region by the seventh century BC; the vessel was also adopted in mainland Greece, together with its western colonies in Gaul and southern Italy. Distinctive Greco-Italic types emerged by the third century BC, and these were the immediate progenitors of characteristic cylindrical amphorae (Dressel form 1), which carried exports of Italian wine all around the west Mediterranean and beyond in the first century BC. The distinctive form of the handles and basal spike were well adapted to the requirements of shipping; excavated shipwrecks show that amphorae were arranged vertically in several layers, with their pointed ends fitting neatly and securely between the necks of vessels in a lower layer. The large handles also facilitated unloading. Amphorae are particularly important in the study of Roman agricultural production and trade, and their interpretation combines careful studies of forms with scientific analyses of the clays from which they were made.

The rise of provincial pottery industries

The extension of their power north of the Alps brought the Romans into close contact with Celtic and Germanic peoples who did not share their background of

Mediterranean culture with its unifying long-distance seaborne trade in oil, wine and grain. These 'barbarian' peoples did, however, enjoy a prosperous agrarian and stock-raising economy; many also used coins and lived in a hierarchy of settlements not unlike that of the Roman world, ranging from hill-forts with some urban features (*oppida*) to isolated farms. Many crafts were already carried out by specialists; potters possessed a wide repertoire of techniques, forms, surface treatments and decorative styles. Since the Celts had for many centuries traded slaves, metals and agricultural products with the Greeks and Phoenicians in exchange for 'luxury' items such as wine, metalwork and fine pottery, the pottery brought into newly occupied areas for use by the Roman army (terra sigillata and other fine wares) did not introduce many novelties. In fact, the 'native' kitchen and storage vessels made in conquered areas were not markedly different from those of Italy, and were normally adopted by the invaders once they had established permanent garrison forts with secure supply lines.

Studies of kiln sites show that some specialised vessel forms, such as flagons, were rapidly added to the repertoire of local potters. In addition, evidence of new forms and techniques indicates that some potters set up production centres in newly conquered provinces. Name-stamps on terra sigillata, lamps and mortaria (fig. 3) all confirm that some manufacturers either migrated to new provinces or set up branch workshops, presumably to avoid the high transport costs which would otherwise be involved in supplying new markets created by Roman soldiers and civilians, and the increasingly 'Romanised' tastes of natives of the provinces. We are particularly well informed about the diffusion of terra sigillata production from Italy to the provinces during the period of the Roman empire because some of this pottery was made in moulds with distinctive styles of decoration, and the majority of plain vessels were stamped with the potter's name. These features, combined with detailed typological studies, allow us to identify production centres, and this can be corroborated by scientific analysis. Thus it is possible to follow the changing fortunes of production centres in different locations through time; indeed, it is even possible to follow the careers of individual potters who stamped their names on vessels made at separate places at different times.

From the end of the first century AD, sites around the Mediterranean were increasingly supplied with Red Slip Ware from North Africa and Asia Minor (fig. 13) rather than terra sigillata made in Europe. Although sharing common origins, these wares developed away from each other after the first century AD. Interesting observations have been made about these two kinds of tableware in Spain. Italian and Gaulish terra sigillata were imported at first; local production then developed in the late first century AD which lasted well into the second century. However, the displacement of traditional terra sigillata around the western Mediterranean by African Red Slip Ware was reflected in the next phase of tableware production in Spain, in the fourth century AD, for its forms and decoration were modelled on Red Slip Ware rather than on terra sigillata. As was to be the case during much of its early medieval history, developments in the Iberian peninsula were more closely related to North Africa than Europe.

The frontiers

In the 1920s a team of German archaeologists studied sites belonging to military campaigns of the second to first centuries BC around Numantia in central Spain –

an area well away from the Mediterranean coast, where Greek and Roman influence had already been strong for several centuries. The pottery they discovered and published includes imported Campanian tableware and fine drinking vessels (from Italy or the coast), as well as mortaria, flagons, jars and bowls of Italian forms. However, considerable quantities of local Iberian and Celtic pottery were used alongside these imports. Pottery found on military sites in other parts of the empire conforms to the situation observed at Numantia: local, 'native' pottery was always used by the army as long as suitable wares and forms were readily available.

Military production
Roman military units included skilled artisans adept at metalworking and building construction, and they frequently established facilities for the manufacture of bricks and roof tiles stamped with the name of their unit or legion (fig. **30**). If local pottery supplies were inadequate – for example in northern parts of the Rhineland or in northern Britain and Wales – they also turned their hands to potting. Since many soldiers had been recruited in Italy or heavily Romanised provincial cities, the majority of the vessel forms made by military potters are closely comparable to those found in Italy itself, with the addition of some forms which display Celtic influence (fig. **4**). Military production tended to be short-lived, for when frontier areas were stabilised, supplies could be brought safely from non-military sources in the hinterland (fig. **5**). Alternatively, civilian potters might set up production in a military region in order to take advantage of new markets created by forts and the civilian settlements which grew up around them.

Unusual pottery has been found on the sites of several frontier fortresses occupied by Roman legions from Britain to the Danube. It reveals an interesting episode in military pottery production between *c.* AD 70 and 120. The pottery is very impressive and includes finely made tableware, frequently imitating the shapes of vessels normally made of glass or metal (fig. **6**). It is difficult to interpret, but clues are given by unusual techniques of manufacture and decoration, including painting, moulding and glazing, which indicate that the potters may have come from areas near Greece or Asia Minor. The forms made by these potters suggest that they might have been put to work to solve temporary difficulties in the supply of metalwork, glass or terra sigillata. If so, the need was short-lived, for this phase of military manufacture ended early in the second century AD and was never repeated. The phenomenon does, however, illustrate the way in which examples of military supply arrangements can be deduced by careful studies of the form, date and distribution of pottery; such information is rarely available from Roman documentary sources.

Army supply
Hadrian's Wall formed the northernmost boundary of the Roman empire for more than two centuries. Upwards of five thousand soldiers occupied garrison forts on the Wall itself, with at least as many again in the immediate hinterland; many more army dependents lived in the towns and settlements which sprang up around military centres. Although no suitable local 'native' pottery was available for use, careful study of pottery found in the region demonstrates that normal channels of supply from civilian industries were capable of sustaining these consumers, with little necessity for military production. What is more, few

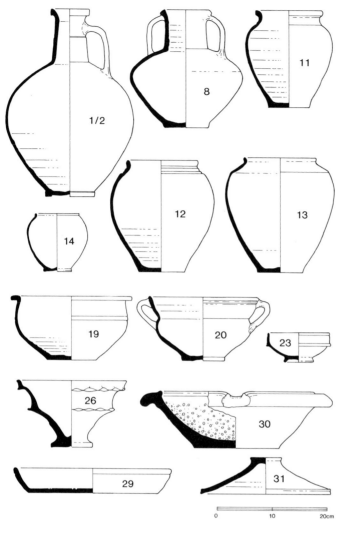

4 The principal forms made at the legionary fortress at Usk in Wales around AD 60 by potters (probably soldiers) working in the same tradition as their counterparts in the Rhineland. The forms share Italian and provincial origins, and two jars, types 12 and 13, have close parallels in Switzerland and eastern France which imply that a potter had been recruited from a Romanised centre in that region such as Lyon or Augst.

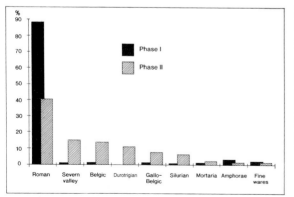

5 (*below*) Sources and functions of pottery (other than terra sigillata) excavated at the Usk legionary fortress. In Phase I most of the pottery was made at the site (fig. **4**), but after the fortress had closed down the reduced garrison used pots from many sources in Phase II. The graph below shows that the functions of the vessels remained much the same, while the graph on the left demonstrates that supplies were drawn from a much wider area after the region had been pacified.

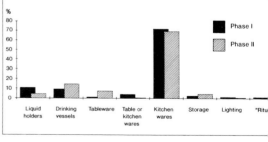

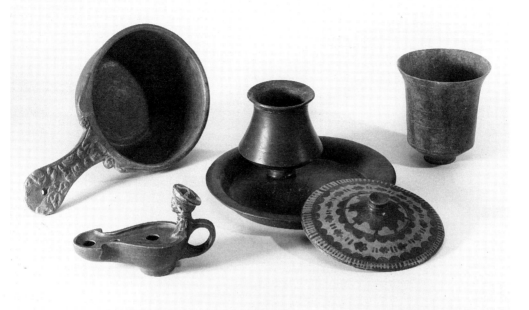

6 'Wetterau ware' from the Roman fort at Heddernheim near Frankfurt in Germany. Elegant and expertly made pottery of this kind was manufactured at many military centres in the late first and early second centuries AD, and these wares are frequently termed 'legionary'. Some forms suggest that potters from Greece, Asia Minor or Africa were employed to supply alternatives to terra sigillata, glass and metal vessels as part of military supply policy.

potters moved north to set up production in the immediate vicinity of the forts; normally pottery came from sources which supplied identical pottery to the civilian market further south.

Thus a soldier in a garrison fort around AD 200 would use terra sigillata from central and eastern Gaul, fine drinking vessels from Trier in the Mosel valley, mortaria from Northamptonshire or Warwickshire and robust cooking pottery from the south coast or the Thames estuary; oil and wine arrived in large amphorae from Spain and North Africa. It is remarkable to consider that, although sources had changed, these categories of pottery differed little from those found in Italy two centuries earlier. Only in the late fourth century AD when the size and status of the Wall's garrison had declined dramatically, did the bulk of the pottery used in the Hadrian's Wall region come from a single source (with the implication that official organisation was involved). Even then, the source was over 100 km to the south, in Yorkshire, and a respectable range of cooking pots, mortaria and tableware was still supplied. Such observations have significant economic implications; the interpretation of the possible marketing mechanisms involved in the supply of pottery to the frontiers will be discussed in chapter 7 (see pp. 58-60).

— 2 —

The Development of Roman Pottery Studies

Roman pottery studies reflect many of the general trends that have influenced the development of archaeology as a whole. The study began with nineteenth-century antiquarianism and became more rigorous as working methods improved along with excavation techniques in the early twentieth century. The problems of dating which dominated the objectives of most researchers until the 1960s remain important, but the influence of laboratory science, anthropology and computer technology have dramatically extended the scope for interpretation during the last three decades. These themes are introduced in this chapter and then explored in more detail throughout the rest of the book.

Pottery in Roman literature

Pottery is unfortunately notable for its almost complete absence from the surviving Greek and Roman literature which has formed the starting point for studying many aspects of classical archaeology since the Renaissance. For example, Pliny the Elder's encyclopaedic *Natural History* runs to ten volumes in the modern Loeb edition and contains very detailed discussions of many topics of profound archaeological significance, such as mining and metallurgy. Pliny does actually mention a few pottery production centres in Italy, Spain and Asia Minor, and records Arezzo's high reputation for 'Samian' tableware. Unfortunately, he then lapses into tedious anecdotes, ranging from the price Aesop paid for a dish to the idiosyncrasy of priests who castrated themselves with sherds of Samian pottery. Next to nothing is said about technology until Pliny moves on from pottery to various kinds of mortar, and then to brickmaking. Any disappointment that archaeologists may feel, however, might be tempered by the fact that this leaves them free to make their own interpretations, with little constraint from written texts.

Archaeologists must not be misled by the fact that such large quantities of pottery survive into thinking that it was more significant to the Romans than the literature implies. However, classical archaeologists and historians should also avoid making the equally serious mistake of ignoring interpretations based upon ceramic evidence; they must remember that cooking pots reflect the daily lives of

ordinary people, very different from the social élite who wrote most of the surviving literature.

Fortunately, some historians of the ancient world have taken note of the fact that name-stamps and other informative inscriptions frequently appeared on some forms of pottery and tiles. Hundreds of examples from Rome were collected and published in 1899 by Heinrich Dressel, long before detailed archaeological studies of pottery had helped to throw more light upon their meaning. Many of Dressel's examples were collected from the Monte Testaccio (literally, 'hill of potsherds'), a vast heap of broken amphorae near the banks of the river Tiber in Rome. Many more are discovered on other sites every year, and particularly good examples come from the excavation of shipwrecks, in which complete amphorae may still bear details written in black ink about their origin, weight and contents, as well as names of potters or estate owners stamped on to their handles. This kind of written evidence is exceptionally useful for the interpretation of trade.

The only other sources likely to provide further useful information are documents written on wooden writing-tablets or papyrus. Writing-tablets only survive on sites with permanently waterlogged deposits, while papyri are virtually unknown outside dry sites in Egypt and have only been recovered since serious excavations began to be conducted in the nineteenth century. Helen Cockle has published a fascinating papyrus document dating from AD 243 from Egypt, which gives a detailed account of leasing arrangements whereby a workshop made wine jars for an estate owner; this is exactly the kind of information that could not be discovered on a kiln site through excavation alone.

Objets d'art

Two important features of European cultural life by the eighteenth century were the formation of collections of antiquities and the 'Grand Tour' of Greek and Roman sites around the Mediterranean. Greek antiquities proved more attractive than their Roman equivalents, particularly in the case of pottery. Most collectors were eager to lay their hands on large Greek vases with elaborate hand-painted black and red figural scenes; by chance, these were usually recovered complete from burials. Even the very finest decorated pottery vessels produced at Arezzo in Italy in the reign of Augustus (27 BC–AD 14) were moulded rather than individually painted and lacked any variation from a uniform red colour. Their only saving graces were recognisable scenes from classical mythology and potters' names included in the decoration or stamped on the vessel during manufacture. Perhaps the most collectable Roman ceramic items at this time were lamps, which made relatively cheap and easily transportable souvenirs and were often enlivened with interesting moulded motifs, including erotic scenes. Unfortunately, the popularity of lamps has led to a long history of counterfeiting, and an expert eye is required to separate the genuine from the false – confirmed, where necessary, by appropriate scientific tests (see chapter 4).

For those who could not afford the Grand Tour around the Mediterranean, graves in the northern provinces of the empire occasionally yielded complete examples of 'Samian' ware (a misleading name given to provincial derivatives of Arretine terra sigillata). Other 'fine wares' made locally in Gaul, Germany, Britain and elsewhere attracted the attention of antiquarians who shared the growing interest in local sites and artefacts, rather than those of distant Mediterranean countries. These were usually drinking vessels with a dark glossy surface,

decorated free-hand with animal and plant motifs that did not meet with the approval of collectors with strict classical tastes. One British antiquary, Thomas Artis, was sufficiently interested in this kind of pottery to carry out excavations in Northamptonshire, and to publish (in 1828) illustrations of typical products and the kilns in which they were fired (fig. 7).

The British Museum acquired major pieces of classical sculpture from the Townley Collection in 1805, but a second tranche in 1814 included terra sigillata vessels from a shipwreck site off the north coast of Kent ('Pudding Pan Rock'). A very significant purchase (in 1856) was the Roach Smith Collection, which comprised finds from the City of London and was described in a British Museum catalogue of 1908 as 'one of the largest and most representative collections of Roman pottery from any one site'; Charles Roach Smith had published good illustrations of pottery from Britain and France as early as 1848. Other purchases of Romano-British collections from Lincoln and Colchester followed in 1866 and 1870. The museum's holdings were broadened between 1893 and 1900 by a range of Italian terra sigillata from Arezzo and in 1901 by the Morel Collection from Rheims, which added material from Gaul. These extensive purchases enabled H. B. Walters to publish an extensive *Catalogue of the Roman pottery in the Department of Antiquities in the British Museum* (1908). However, Walters' enthusiasm for Roman pottery should not be overestimated. His two-volume *History of Ancient Pottery* (1905) does not introduce Roman pottery until page 430 of the second volume, and even then it follows discussions of ceramics in Roman architecture, terracotta sculptures and moulded lamps. Walters clearly reveals the prevailing attitude among classical archaeologists at the time:

> Roman vases are far inferior in nearly all respects to Greek; the shapes are less artistic, and the decoration, though not without merits of its own, bears the same relation to that of Greek vases that all Roman art does to Greek art.

Fortunately, such prejudices did little to inhibit the appearance of regional

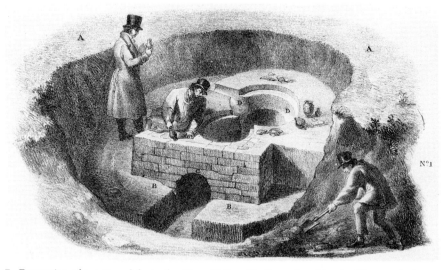

7 Excavation of a pottery kiln in the Nene Valley, Northamptonshire, by Thomas Artis, a pioneer in the publication of kiln excavations, in 1828. Recent discoveries have confirmed the accuracy of his observations (see fig. 24).

studies of Roman pottery. An enterprising book was published in 1897 by O. Hölder (*Die Formen der römischen Thongefässe diesseits und jenseits der Alpen*) which compared pottery found at Roman forts in Germany with forms from Italy; this was possible thanks to cemetery excavations in the north, together with complete vessels recovered from Pompeii and Herculaneum. The importance of finds from production sites was emphasised in Joseph Déchelette's *Les vases céramiques ornés de la Gaule romaine* (1904), a work full of excellent drawings of decorated terra sigillata and other fine wares from France.

Classification

The nineteenth century marked the beginning of a scientific approach to archaeology, largely stimulated by progress in geology and biology. A strictly art-historical approach was now tempered by a desire for rigorous classification and dating and, if possible, a sense of the evolution of forms and styles over time (typology). The influence of ethnography meant that attention also began to be devoted to 'ordinary' objects of all periods, not just to major antiquities from the great civilisations of the Mediterranean and the Near East. Serious archaeological study of Roman pottery finally began, fortunately coinciding with the transition of excavation from little more than looting to a systematic method of investigating sites.

One example of typology was published in 1895 by Dragendorff, a German who had recently completed a doctoral thesis on classification and dating of terra sigillata. It remains in use to this day and allows archaeologists to use brief descriptive terms like 'form 29' (rather than 'mould-decorated bowl with carinated wall and everted rim') when describing a common vessel of the first century AD. Dragendorff used the growing number of recorded graves containing pots associated with coins, combined with a few historically dated sites, to establish the chronology of each form. Dressel (another German scholar, working on Latin inscriptions from Italy) devised a numerical scheme for describing the shapes of amphorae and published it, with drawings, in 1899. Unlike Dragendorff, his objective was not to assist excavators or museum curators but to relate the forms of the vessels to the inscriptions stamped or painted on to them.

Amphora specialists have been in the difficult position of needing to expand, refine, modify or replace Dressel's classification ever since 1899. Perhaps the most successful attempt has been Peacock and Williams' *Amphorae and the Roman economy: an introductory guide* (1986), because it includes details of the geological characteristics of the clay fabric of each form as well as its shape and the likely contents (oil, wine, fish sauce, etc.). Various excavators have added new forms to Dragendorff's type-series, but it took almost a century of further studies of terra sigillata from excavations, combined with scientific analyses, before an international team of specialists could produce the *Conspectus formarum terrae sigillatae italico modo confectae* (1990), a comprehensive new classification and dating of vessels made in Italy. These publications illustrate an interesting contradiction inherent in many academic disciplines: pioneers can make great strides based on common sense and limited evidence, but further progress requires much more detailed research into many different aspects which can no longer be carried out by any individual scholar. The more specialised and disparate the research becomes, the harder it is for an archaeologist to make general interpretations that do not gloss over unresolved ambiguities in the evidence.

Dating

For some areas of the Roman empire where historical documentation is at best fragmentary (notably in 'fringe' areas such as Britain and Germany), archaeologists began to realise that some distinctive forms of pottery might provide an alternative means of dating sites. Large quantities of pottery were found in excavations on military sites on the German frontier in the late nineteenth century, and some of it was carefully drawn and published (fig. 8). Robert Knorr studied decorated terra sigillata and potters' stamps from several forts which could be dated by a combination of historical and archaeological evidence, and published several catalogues in the early 1900s. In 1919 he published *Töpfer und Fabriken verzierter Terra-Sigillata des ersten Jahrhunderts*, which defined and dated terra sigillata made in southern Gaul in the first century AD; Knorr's own fine accurate drawings have rarely been equalled since. His achievement allowed products from workshops in Gaul to be used to date sites anywhere in western Europe, thanks to the wide distribution of south Gaulish terra sigillata.

In 1909 Siegfried Loeschcke illustrated a much wider range of pottery (including kitchen and tablewares other than terra sigillata) from Haltern, a short-

8 The Rhine–Danube Roman frontier system in Germany, showing lines of forts dated by a combination of historical and archaeological evidence. Finds from excavations on these sites form vital reference collections for the chronology of pottery on undated sites elsewhere.

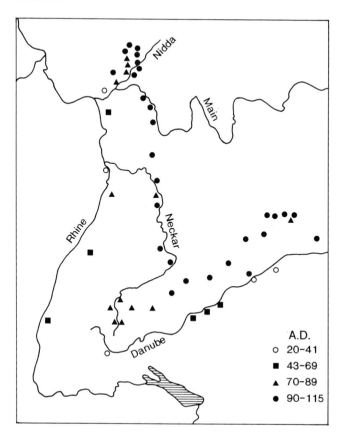

lived fort east of the Rhine dated on historical grounds and by coins to *c*. 7 BC–AD9. In 1912 Hagen published the products of military kilns which supplied coarse pottery to forts on the Rhine at Remagen and Xanten. The implications of these sites in Germany were soon applied elsewhere – for example by J. P. Bushe-Fox, whose examination of the use of terra sigillata in dating the early Roman occupation of the north of Britain was published in 1913. By 1920 sufficient dated sites had been studied for Felix Oswald and T. Davies Pryce to publish *An introduction to the study of terra sigillata*, a 'standard' reference work on typology and dating which embraced all of the major production centres.

Ordinary earthenware (commonly known as 'coarse' pottery) presented more problems, for it is less standardised and was made in many more centres than terra sigillata. In 1950 Erich Gose published a guide to the dating of forms found in Germany, and John Gillam performed the same service for northern Britain in 1957, using the dating of periods of occupation on Hadrian's Wall as his framework. Perhaps the most important achievement of these writers, together with other pioneers, is that they firmly established the principle that *all* kinds of pottery are important to the dating of a Roman site, and that no site report is complete without a detailed account of its pottery, illustrated by accurate scale drawings. Unfortunately, this principle did not begin to be observed in some other areas of the Roman world until the 1980s; ironically, full publication of pottery is fast becoming a victim of cuts in the funding of archaeology in Britain and the other countries where its serious study began.

Some preliminary work on pottery from the Mediterranean region was carried out before the Second World War. The Dutch scholar Holwerda attempted an overview of ordinary wares, rather than just luxury tableware, but it was based on a museum collection rather than fieldwork (*Het laat griekische en romeinsche Gebruiksaardewerk uit het Middellandsche-Zee-Gebied*, 1936). The relationship of Roman pottery to its Greek background began to be revealed by publications of sites such as Olbia in south Russia (1929), Antioch in Syria (1934–48) and the Athenian Agora in Greece itself (1933). However, excavations conducted along rigorous stratigraphic principles remained rare in the Mediterranean region; archaeologists had to wait until 1972 for the publication of *Late Roman pottery*, John Hayes' detailed reference work on the classification and dating of Red Slip Ware, which plays a role in dating Mediterranean sites equivalent to that of terra sigillata in the north-western provinces of the empire.

Pottery and economics

Until the 1970s Roman pottery was regarded primarily as an aid to the dating of sites, but it eventually began to take its rightful place in wider works on Roman archaeology. Initially, however, this potential source of information was not pursued by pottery specialists. The pace of industrialisation in nineteenth-century Europe promoted an interest in the history of technology, and Greek and Roman pottery production were first considered by early exponents such as H. Blümner in his *Die gewerbliche Tätigkeit der Völker des klassischen Alterthums* (1869).

Rostovtzeff's influential economic history of the Roman empire (1926) made only superficial reference to the production of terra sigillata and lamps. However, in contrast, and also in 1926, M. P. Charlesworth used all kinds of archaeological evidence, including pottery, to extend the limited range of written evidence for trade routes. Tenney Frank, editor of an ambitious five-volume *Economic survey of*

ancient Rome, invited a pottery specialist (Howard Comfort) to write a section on terra sigillata (1940). Charlesworth, Rostovtzeff and Tenney Frank all took amphorae into consideration in the study of trade, but they used Dressel's evidence derived from stamps on their handles or inscriptions on their bodies rather than the forms of the vessels themselves. Sophisticated deductions about the Roman economy only began to be drawn from pottery after much more excavation and fieldwork had taken place.

Anthropology and analysis

Even before the nineteenth century, archaeologists involved in the study of prehistory had looked to anthropology and ethnography for explanations of societies and their material cultures. This phenomenon underwent a renewal in the influential 'new archaeology' of the 1960s, when Lewis Binford and others extended this approach by adding supposedly 'scientific' testing of theoretical models of human behaviour. In effect, it transpired that most models could only be validated by comparisons with surviving pre-industrial societies; as a result, renewed effort was put into anthropological fieldwork in many parts of the world. Some of this work incorporated studies of pottery production and marketing, with important implications for the study of Roman pottery.

Scientific analyses of Roman pottery occasionally took place in the nineteenth century – some had been specially commissioned by Dragendorff for his classic publication on terra sigillata (1895) – but they did not become a routine part of its study until after 1950. Papers on pottery became a regular feature of *Archaeometry,* a periodical devoted to the publication of the results of archaeological science which was established in 1958. Some were specifically concerned with Roman pottery – investigations of mortaria and terra sigillata appeared in 1959 and 1960. Two notable names in the development of scientific pottery studies also began to crop up frequently: David Peacock from 1967 (writing on heavy mineral analysis) and Maurice Picon from 1971 (the composition of terra sigillata from Lezoux, Lyon and Arezzo). More specialised research also made an appearance, for instance an attempt to identify traces of oil in ancient amphorae in 1976.

David Peacock's research interest in Roman amphorae led him to travel widely around the Mediterranean, where he combined analysis with anthropology by observing traditional pottery industries in action. He studied the economics as well as the technicalities of their operations, and published a

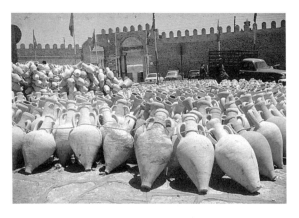

9 Modern amphorae, very similar to Roman vessels, photographed in 1974 at Kairouan (Tunisia). The interpretation of ancient ceramics can be clarified by careful observation of modern pottery manufactured by traditional methods. The economics of production and distribution also provide interesting analogies which may help to explain how Roman industries operated.

brief examination of Roman bricks and tiles from an ethnoarchaeological standpoint in 1979. However, this was only a prelude to Peacock's pioneering book, *Pottery in the Roman world* (1982), which synthesised scientific analysis, ethnographic observation and economic theory (fig. 9). Students of Roman pottery today require a good understanding of all three sources of evidence before they can safely begin to put forward any serious interpretations.

A modern crisis

The 1970s and 1980s witnessed a boom in archaeological excavation and fieldwork all over Europe and around the Mediterranean, frequently initiated by threats of imminent destruction by urban expansion or rural development. The boom had the beneficial effect of making masses of pottery from controlled excavations available for research, and thus generated some interesting publications. It also led to a crisis, for pottery specialists now found themselves unable to cope with the processing and interpretation of such large quantities of material for publication without a radical review of their working methods, if they were to meet the new higher standards.

Some of the trends introduced or emphasised by the 'new archaeology' in the 1960s proved very useful in the context of processing pottery for publication. The use of statistics allowed large assemblages to be quantified and summarised very concisely, while the concepts of model-building and hypothesis-testing gave a sharper focus to the reasons for studying and publishing pottery, thus adding more weight to the interpretations which emerged. Interestingly, some of the papers published in the early 1970s which helped to demonstrate the validity of these approaches to Roman pottery were written by Ian Hodder, before he turned to more general problems in anthropology and became a well-known figure in debates about archaeological theory.

The most important practical factor to influence pottery studies in the 1970s and 1980s was the rapid growth of computer technology. As early as 1976 John Riley published a paper on the quantification of Roman pottery in the Mediterranean in a conference report (*Computer Applications in Archaeology*); computer data-processing has become commonplace since then. Microcomputers are now relatively cheap, and ready-made programs make it easy for pottery specialists, rather than computer experts, to collect and organise their information, calculate statistics, draw graphs and prepare the text of their reports.

The 'desk-top publishing' revolution of the later 1980s has taken the process a stage further, allowing excavators to design, compile, print and publish their own reports, without having to face the inevitable costs and delays of traditional commercial publishing. However, this can amplify the problem, rather than provide a solution. Directors of excavations may feel unable to publish full site reports containing the vast quantities of data processed by their pottery specialists, and pottery reports may simply be relegated to archives or separate publications. Excavators thus run the risk of neglecting the vital procedure of integrating their site and its finds – a process which *should* enhance the interpretation of both.

— 3 —

Dating and Classification

Roman pottery shares a characteristic with ceramics of other periods in that it can hardly ever be dated *directly*. A rare exception emphasises this problem, and underlines some of the difficulties inherent in all archaeological dating. We know from fragments of decorated bowls that when the emperor Trajan completed the conquest of Dacia (modern Romania) in AD 107, a terra sigillata workshop in southern France marked the event by including an inscription in their moulded decoration, recording the suicide of the Dacian leader Decebalus in AD 106 (fig. **10**). It is instructive to consider what conclusions could be drawn from one of these bowls found on an excavated site.

It is obvious that the mould must have been manufactured after news of the death of Decebalus had reached Gaul – but was that a matter of days, weeks or even months? How soon did the mould go into operation, and for how long was it used? We can probably assume that it would not have survived beyond the end of the reign of the victorious emperor Trajan (AD 117), for the event commemorated would have seemed rather *passé* under his successor Hadrian. The finished bowl did not necessarily leave the kiln site immediately after its manufacture; it may have been stockpiled to await the completion of a consignment ready for transport. The voyage by road, river and sea would have been slow, and further delays could arise in warehouses at the receiving port as well as in subsequent distribution to a shop or military quartermaster. The bowl might well have taken a year to reach its first owner, and we know from our own everyday experience that ceramics can last for decades, even in daily use. It is impossible to tell whether a bowl found in fragments in an excavation was broken and thrown away after a short active life (perhaps one to five years) or after a longer period of occasional use (twenty years or more).

So how may this bowl be interpreted for dating purposes? The death of Decebalus in AD 106 provides a fixed point *after* which the mould must have been made, and it is unlikely to have been used beyond AD 117. The interval between manufacture and disposal after breakage on the site where it was used *could* have been as little as one year, but common sense suggests that this period is likely to have been much longer. Thus, although the manufacture of the pot in question can be dated with some accuracy, this only provides a fixed point after which the

excavated deposit in which it was found must have formed (archaeologists call this a *terminus post quem*). For most pottery the situation is reversed, for it has to be dated indirectly, by assigning a date to the location of its discovery. What is actually being dated, therefore, is not the manufacture of a piece of pottery, but its breakage and disposal.

Dated sites

Frontier forts

Fortunately, it is possible to use historical sources or inscriptions to fix the date of many sites or structures in the Roman world, but only occasionally can both the upper and lower limits of a date-range be established. A good example results from an attempt by the emperor Augustus (27 BC–AD 14) to establish garrison forts in Germany in the area between the Rhine and the Elbe rivers. This process began in 12 BC but was curtailed in AD 9 because of a dramatic ambush and defeat of three legions, after which Roman forces were permanently withdrawn back to the west bank of the Rhine. These dates come from reliable Roman historical sources, but they have also received independent confirmation from finds of coins and from

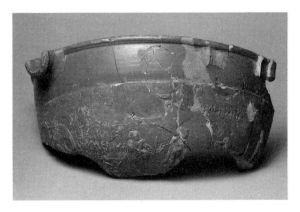

10 (*left*) Moulded terra sigillata bowl (form 37) made in southern Gaul, dated to the early second century AD by an unusual inscription recording the defeat of the leader Decebalus in AD 102, during the emperor Trajan's conquest of Dacia (modern Romania). Unfortunately, it is exceptionally rare for pottery to be dated directly in this way.

11 (*below*) A drawing of the historically dated Decebalus bowl (fig. **10**) appeared in Dechelette's important book on pottery industries in Gaul published in 1904. The text surrounding the name *Decibale domenus* is not clear, but another part of the inscription includes Trajan's title *Parthicus* (conquerer of Parthia), received in AD 116; the bowl may have celebrated several of Trajan's achievements.

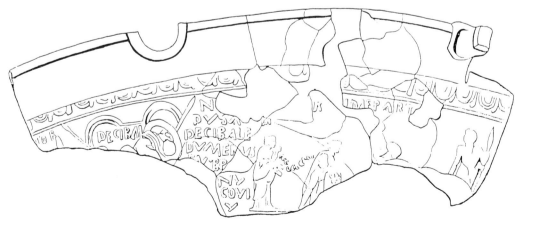

dendrochronology, by which the dating of tree-ring patterns in wood used in the construction of the forts has been shown to correspond with the historical evidence.

We saw in chapter 2 that, as early as 1909, Loeschcke had illustrated coarse pottery and terra sigillata from one of these Augustan forts, Haltern. Since the 1970s Siegmar von Schnurbein has investigated and published the actual pottery production facilities of this well-dated fort. Haltern and related sites therefore provide us with an excellent 'reference collection' of securely dated Augustan pottery, with which finds from other areas can be compared. Subsequent developments on the German frontier in the first century AD are also reasonably well documented in Roman historical sources (fig. 8). In addition, by 1919, Knorr had worked out the active periods of many terra sigillata workshops in southern Gaul by recording the occurrence of potters' name-stamps and their distinctive decorative styles on vessels that were exported to forts of different dates in Germany.

The quality and detail of documentary sources deteriorated after the first century. At the same time the European frontiers underwent less rapid development once the Romans had settled upon the rivers Rhine and Danube as the principal northern boundary of their empire. An exception was northern Britain, where Hadrian personally supervised the establishment of a great stone wall to demarcate the northern limits of the Roman world in AD 122. His successor, Antoninus Pius, reversed this decision and advanced the frontier into Scotland, where the rather less impressive Antonine Wall was constructed between AD 138 and 142. Careful excavation of the earliest occupation deposits in forts on both walls have revealed reference groups of Hadrianic and early Antonine pottery, but because the frontier oscillated between the two lines for the rest of the second century AD, excavators require the assistance of coin and pottery specialists to sort out the complexities of later phases of occupation.

Civilian sites
Dating is even more difficult away from military frontiers, for it is rarely easy to relate civilian buildings or phases of sites to historical events with complete confidence. Only a cataclysmic event provides real certainty: the best example is the eruption of Vesuvius in AD 79, which sealed Pompeii and Herculaneum under layers of ash and mud. Some well-recorded buildings in these towns actually contained pottery items which were in use at the time of the eruption. The dating value of Pompeii for pottery specialists was emphasised in 1914, when Donald Atkinson published a hoard of ninety decorated terra sigillata bowls, made in southern Gaul and found in 1882 along with thirty-seven pottery lamps. Since this consignment of pottery was found in the charred remains of a packing-case, it is assumed to have been delivered to Pompeii shortly before AD 79, but this date is only an upper limit (a *terminus ante quem*), as it is impossible to know how long beforehand the pots were actually manufactured.

Thanks to the fact that south Gaulish sigillata had a very wide distribution which included much of the western half of the empire, the decorative styles and potters' stamps found at Pompeii could be used to date vessels excavated elsewhere. Atkinson noted that the consignment included twenty-six bowls of Dragendorff's form 29 and fifty-three of the more recently introduced form 37. He compared the ratio of the two forms to that of bowls excavated at forts in Germany and (fortunately) established a good correlation between Pompeii and German sites dated to the same period by historical sources.

Other non-military sites are notoriously difficult to date. Many Roman colonies, cities and towns were founded in Italy and the provinces at known dates, but it is very important to establish whether the earliest deposits have actually been found. In many cases, some kind of settlement already existed; we know the date of the Roman acquisition of Provence (122 BC), but cities such as Marseilles had been founded as Greek trading colonies several centuries earlier. It would be unrealistic to expect that distinctive archaeological deposits or new forms of pottery would mark the precise point at which the inhabitants became 'Roman'. Some sites suffered destruction at specific dates mentioned in historical sources – the burning of Colchester by Boudicca in AD 60 or the sack of Rome by Visigoths in AD 410. Contemporary historians frequently exaggerate, however, and it is also notoriously difficult to distinguish between the physical consequences of an attack and the effects of purely accidental burning or intentional demolition of buildings; both were common in Roman towns.

Individual buildings dated by historical texts or inscriptions are more likely to yield useful dated finds. But not even inscriptions provide certainty, for emperors were quite capable of claiming full credit for constructing a building which they had merely modified or repaired. Furthermore, buildings mentioned in historical sources have attracted rather too much attention over the years. Many structures in the Roman Forum were studied by Renaissance architects and then plundered for their stone. Most were also cleared out by antiquarians interested only in large impressive sculptures or inscriptions – before the twentieth century, fragments of pottery would scarcely have been looked at, let alone recorded or preserved.

Stratigraphic excavation

It should be clear from the problems outlined above that historical dating can only be applied to pottery once significant quantities have been excavated from sites. Furthermore, unless dated sites had an unusually short lifespan, it is essential that the pottery has been excavated with attention to the contexts in which it was found – occupation layers, foundation deposits, destruction levels, rubbish pits, etc. This kind of stratigraphic excavation has only become standard practice in the twentieth century. Once significant deposits have been identified, they can be checked by means of diagnostic types of pottery (such as terra sigillata) which have been dated elsewhere, or by coins found with the pottery. Well-dated pottery must be published in detail if this checking procedure is to continue, thereby allowing dates to be applied to other sites where historical clues are absent. It must be stressed that the interpretation of stratified deposits encountered in an excavation is a skilled but subjective task. Pottery specialists should always check published excavation reports rather than take the excavator's evaluation on trust.

The Roman coastal city of Cosa in Italy provides an excellent early example of an integrated approach to historical documentation, stratigraphic excavation and the study of carefully selected deposits of pottery. The American Academy in Rome has published a series of reports on various kinds of pottery from the site, and the first of these, in 1957, set out the detailed evidence for each selected deposit. It is particularly important to have information of such high quality from Italy, for this allows us to study the Italian antecedents of pottery forms introduced to the provinces.

Typology

Typology was one of the most important developments in archaeology in the nineteenth century; it arose from a belief that orderly classification would reveal the evolution of forms and styles of all kinds of artefacts, including pottery. One of its underlying principles is the assumption of technical progress – for example, that a more efficient form of axe will soon supplant a less efficient one. It is difficult to apply this principle to most sorts of Roman pottery, for minor permutations observed in rim-forms or handles seem to bear little relevance to their function. Nevertheless, some of these changes are at least consistent over time. A Black Burnished Ware cooking pot of the early second century AD from Hadrian's Wall will have a fairly upright rim whose diameter is smaller than the maximum girth of the vessel, while a fourth-century cooking pot has a narrow body and a flattened rim that projects outwards (fig. **12**).

The date of other Black Burnished Ware cooking pots can be estimated from their degree of similarity to early or late examples. However, the accuracy of this

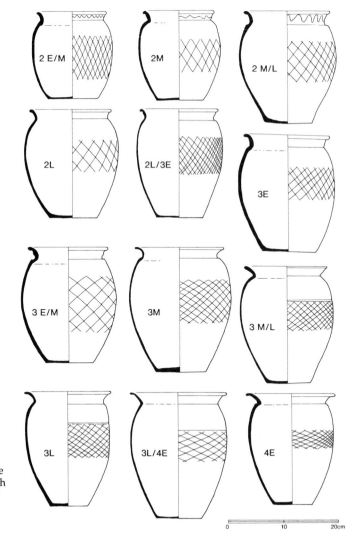

12 Typology of Black Burnished Ware cooking pots from the early second century AD to the fourth century. Finds from dated sites show that the body became progressively narrower and more cylindrical, while the rim was flattened and projected outwards. In addition, the lines in the lattice decoration changed direction in the third century. The century to which each vessel belongs is indicated by a number: E = early; M = mid; L = late.

dating method rests upon the questionable assumption that there was a steady rate of change over time, rather than upright rims suddenly being supplanted by flattened rims. Furthermore, small details of the angle of the rim or the shape of the body should not be compared too rigorously; Black Burnished Ware was handmade in several locations, so we have no reason to expect any degree of standardisation. The solution to these problems is to study sequences of dated deposits from excavations so that the speed of change can be measured. In addition, contexts that formed rapidly may give insights into the extent of variation or standardisation – for example, the kitchen area of a building destroyed by fire should provide a range of cooking vessels, all in use at the same time.

Prehistoric archaeologists faced almost insuperable problems in dating non-functional changes until scientific dating methods became common in the 1960s. As we saw in chapter 2, Roman archaeologists had already begun to build up a series of reliable chronological fixed-points, and careful study of pottery from these sites gave rise to the first useful typological sequences.

The typology of terra sigillata

Dragendorff's classification of terra sigillata published in 1895 was entirely descriptive. By the time of Oswald and Pryce's *An introduction to the study of terra sigillata* (1920), specialists had studied ranges of terra sigillata from kiln sites, and many dated military sites had been excavated. As a result, Oswald and Pryce were able to present drawings of the evolutionary sequences of individual cups, bowls and plates, and to add new forms and variants unknown to Dragendorff. Some vessel forms previously thought to be separate types were found in fact to be stages in a continuous progression. For example, the flat plate (form 18) of the mid-first century AD gradually became deeper, with a raised centre, by the early second; by the late second century it was a wide bowl (form 31) – with the result that a new plate (form 79, similar to the original form 18) had to be 'reinvented'.

Recent research into production centres of terra sigillata has shown that minor sites might diverge from the typological development of the major centres whose products dominated exports to the frontiers. In common with workshops elsewhere in south-western Gaul, potters in Montans made the transition around AD 70 from making a mould-decorated bowl with a distinctly angular profile (form 29) to the hemispherical form 37 (fig. **27**). The new form was simpler to make, and its smooth profile meant that it could be removed from the mould very quickly; a simple footring was then added by hand. At Montans, however, the footring was still moulded along with the bowl, by the same method that had been employed to make the more labour-intensive form 29. Traditional typology would mistakenly have identified the Montans form 37 bowls as an intermediate stage between form 29 (with a moulded footring) and form 37 (with a handmade footring), and therefore of an earlier date than the latter.

Detailed typological study can help to throw light on the organisation and working methods at different kiln sites, and these have implications for the economic interpretation of production. Observations at the largest south Gaulish terra sigillata production site, La Graufesenque, have given insights into the design of the products. Vernhet has defined six 'services' which share standard rim-forms right across the range of cups, plates and bowls at different dates. There was obviously nothing random about the evolution of these designs, and interesting questions are raised concerning the overall organisation of production. We know from potters' stamps that the site consisted of many separate

workshops, so who laid down these design specifications, and why were they so carefully observed? Archaeologists are certainly grateful that terra sigillata potters *did* conform to standard forms and rapidly changing fashions in decorative styles, for this allows much more precise dating than can be achieved with any other class of Roman pottery.

Red Slip Wares
Archaeologists working around the Mediterranean are unable to take advantage of the well-dated typologies of terra sigillata after the first century AD. The focus of terra sigillata production had moved away from Italy early in the first century AD and, as discussed above, consignments of vessels made in Gaul reached as far south as Pompeii by AD 79. Whereas the superb arretine sigillata of the Augustan period had formerly been common all around the Mediterranean, exports of later first-century Italian products only reached sites around the west Mediterranean coasts, the Adriatic and the Aegean.

Major production centres sprang up in Tunisia in the late first century AD, but their red-slipped tableware never matched the high gloss of Italian or south Gaulish terra sigillata. It made little impact north of the Alps, where 'real' terra sigillata of higher quality was readily available. However, African Red Slip Ware is found all around the fringes of the Mediterranean, and it reached well inland in some provinces, for it seems to have travelled along the same trade-routes as grain, olive oil and wine. Its only serious rivals were similar east Mediterranean products, notably Candarlı ware and 'Late Roman C' ware. African Red Slip Ware vessels were initially modelled on terra sigillata forms, but they soon began to diverge along their own lines of development (fig. **13**). Production was not as centralised or technically sophisticated as that of terra sigillata; decoration tended to be stamped by hand, rather than moulded. It was therefore more easily imitated by local potters wherever it was sold, and the market was not completely monopolised by a few major centres. Both of these factors reduced the standardisation of Red Slip Ware, making precise typology and comparative dating between sites much more difficult.

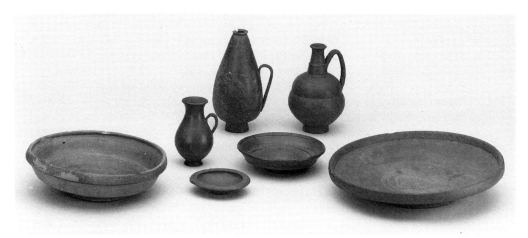

13 Red Slip Ware industries in Tunisia, Turkey and elsewhere around the Mediterranean supplanted terra sigillata in the second century AD. Most vessels are plain, but the tallest jug (*centre*) has applied moulded decoration and the large plate (*right*) has been stamped by hand.

For this reason, the forms of Red Slip Ware vessels could not be classified and dated as easily as those made in terra sigillata. No standard reference work could be compiled until a sufficient number of modern stratigraphic excavations had been undertaken. After two decades of preliminary work by several scholars on sites in different parts of the empire, in 1972 John Hayes established a basic typology and dating for the most important regional variants of Red Slip Ware. Because it was still based on a relatively small number of key excavated deposits, his dates are continually modified as work around the Mediterranean proceeds. For example, recent excavations at Carthage in Tunisia have produced several tons of well-excavated pottery from stratigraphical sequences, along with coins and other dating evidence. The development of underwater archaeology has led to the excavation of several shipwrecks containing Red Slip Ware; these are particularly important because they contain groups of contemporary artefacts, deposited in a closed group when the ship sank.

New discoveries took place at such a rapid rate during the 1970s that in 1980 Hayes felt it necessary to publish a supplement to his 1972 volume. In it he remarks:

> And what of the future? One looks forward to a third phase in the investigation of the Late Roman wares – not long to be delayed, one earnestly hopes – when a fully integrated approach (i.e. stylistic, stratigraphical, quantitative and (selectively) chemical/petrographical) is adopted by all excavators of Mediterranean sites. The first examples of this approach, critical for the rewriting of the economic history of the region, are now beginning to appear.

We can see in chapters 5 and 7 how studies of Red Slip Ware and amphorae from different centres – once they have been classified and dated – can help archaeologists to observe and interpret the ebb and flow of maritime trade around the Mediterranean.

Coarse wares
It is not surprising to discover that the typology and dating of ordinary cooking and storage vessels are even more problematic than for Red Slip Ware. Most major towns and well-populated rural areas in the Roman world were supplied by local potters, who commonly worked in a regional tradition that might predate the Roman period. Unlike tablewares and fine drinking vessels, purely functional pots were not subject to the whims of fashion and might change little over several centuries. Any excavator of a Roman site therefore needs to know something about sources of local pottery, and their individual typologies, before coarse pottery can be of any help for dating purposes.

Research at this detailed local level is unglamorous and time-consuming and has only been carried out in a few areas, such as Britain and Germany, where historical documentation and the survival of sites is poorest (fig. **14**). More than half a century of excavation had been carried out before regional guides to typology and dating were published by Erich Gose in Germany (1950) and John Gillam in Britain (1957). Both utilised whatever independent historical dating was available and supplemented it with other evidence, such as coins found in graves or excavated deposits. Inevitably more information has emerged since the publication of these typologies and, to further complicate matters, interpretations of some of the historical sources have actually changed.

Studies of coarse pottery today tend to be centred upon specific wares or

production sites; typological classification of the products is ideally combined with scientific analysis of clay sources and studies of kilns. Once the geological and industrial background has been established, the distribution and dating of products can be studied through careful examination of excavated sites. Interesting socioeconomic implications can also be gleaned, particularly when finds from sites have been recorded in such a way that statistical comparisons can be made. If the category of pottery studied has a distribution that is at least regional, this kind of research then helps in the dating and interpretation of other excavations conducted in the same region.

Alternatively, studies of coarse pottery may be centred upon a single site. For example, excavations over many years at Exeter have revealed the growth and development of a Roman city from a short-lived military fort of the first century AD. Since little was known of the ceramics of the surrounding region, a careful study was made of the wares and forms which characterised different periods of the site's history. Likely sources could then be identified by means of comparisons with local, regional and distant sites, which made it possible to establish the pattern of supplies to the site. The detailed publication of well-dated pottery from excavated deposits in Exeter itself thus came to form a reference collection for other sites in the region. This principle underlies the study of major sites with long occupations all over the empire; our understanding of Mediterranean pottery would be very poor without similar work at Antioch, Athens, Cosa, Carthage and many other locations. An outline of the practical methods of studying pottery from such sites forms the basis of chapter 5.

14 Once pottery from a site or region has been classified, sherds found in excavations can be recorded quickly and efficiently on printed forms without unnecessary and repetitious descriptions. Furthermore, data standardised in this way is much easier to process in a computerised data management system.

— 4 —

Science and Roman Pottery

Archaeology has always been a multidisciplinary field, and archaeologists specialising in the study of Roman ceramics have been more aware of this than have most other classical archaeologists. Even the simplest studies of dating and classification raise technical questions about manufacture, decoration, surface treatments and firing. Many of these can only be answered by scientific means, and it is interesting to observe that laboratory analyses were conducted over a century ago to investigate the glossy surface and clay of Greek painted vases and terra sigillata. Such studies were motivated more by curiosity than a compelling 'need to know', until specific questions about technology and provenance began to be raised by detailed research into dating and typology.

Scientific dating techniques

Estimation of accuracy is a particularly tedious aspect ... inexperienced practitioners tend to be over-optimistic about accuracy and ultimately this leads to disillusion on the part of the archaeologist. Martin Aitken, 1990

Two methods appear at first sight to offer considerable help in dating Roman pottery: thermoluminescence and archaeomagnetism. *Thermoluminescence* (TL) is based upon a simple principle: crystalline materials such as quartz or feldspar included in clay can trap electrons from natural radioactive sources in the pottery itself and its burial environment. These electrons are released when clay is heated (for example, during firing in a kiln), only to start building up again afterwards. The trapped electrons which have accumulated since firing can then be released by heating in the laboratory, and the effect measured as light. The amount emitted corresponds to the length of time since the sample was fired and the radioactivity to which it has been subjected. Unfortunately, so many variables must be taken into account in turning a laboratory measurement into an actual date that a Roman sample is likely to have an error factor of seven to ten per cent. In practice, a 'date' of AD 200 ± 125 represents only a two-in-three chance that the pottery was fired between c. AD 75 and 325! Thus the principal use for TL is authenticity testing; the question 'Is it Roman?' can be answered with confidence,

but more precise problems, such as 'Is it late second or early third century AD?', must remain a matter for conventional archaeological judgement.

Archaeomagnetism (specifically, thermo-remanent magnetism) can also be used to date fired clay. Like TL, the principle is deceptively simple: the direction of the earth's magnetic field has changed over time, and magnetic particles contained in clay align with the direction that prevailed at the time of their last intense heating (typically, firing in a kiln). The magnetic alignment can be measured in the laboratory and a date calculated by comparison with records of past directions. However, because the clay must not have moved since firing, the technique is restricted to fixed structures such as kilns rather than actual pottery. Furthermore, the earth's magnetic field has wandered erratically; past directions before scientific records began (AD 1576 in Britain) can only be elucidated by studying dated samples provided by archaeologists. Unfortunately, magnetic variations are so localised that good data from one region cannot be applied in another. By chance, the pattern of movement in Britain in the Roman period is particularly unhelpful, for very similar measurements existed at different dates; AD 200 lies uncomfortably close to AD 300, and AD 400 is almost identical to AD 300. Thus archaeomagnetism can merely confirm that a pottery kiln is Roman rather than prehistoric or medieval – a fact that could almost certainly be deduced more easily from other information.

The fact that TL and archaeomagnetism may not prove to be of immediate benefit does not mean that Roman pottery specialists can ignore them. The precision of archaeomagnetism can be improved by archaeologists who excavate kilns with particularly good independent dating evidence. An ideal example would be a kiln used for the production of terra sigillata which went catastrophically wrong and was abandoned with its final load intact and undisturbed inside it. If potters' stamps on the pots in the kiln were paralleled on well-dated sites (for example, on the German frontier) then a date accurate within twenty years could probably be provided for the kiln. Clay samples taken from the kiln structure would thus help to establish a fixed-point on the record of its local magnetic field.

Scientific analysis

Pottery cannot simply be presented to a laboratory for analysis; archaeological science requires an integrated approach, combining archaeological information about kilns and production techniques with problem-oriented investigation. Dragendorff's questions about the strikingly glossy surface finish of terra sigillata were not answered by a simple list of chemical ingredients. More than thirty years of investigations since the early 1940s have gradually elucidated many factors which produced the desired surface finish (sometimes described erroneously as a glaze). It can now be seen to consist of a layer of fine particles fused together by heat during firing, as a result of the selection of clays containing specific minerals and particles of a suitable size. The technique by which a fine slip for the surface was prepared and the temperature at which the finished pots were fired are also known to have been important; experimental kilns and firings have accompanied analyses of sherds.

In the field of Roman ceramics, the best work is carried out by scientists who are equally at home with archaeology and laboratory techniques, who understand the archaeological questions that need to be answered as well as the most

appropriate scientific methods for answering them. However, in the words of one guide to the processing of Roman pottery from excavations, 'It must be remembered that petrologists and chemical analysts with archaeological experience are scarce, and they should not be troubled unnecessarily with routine identifications'. Archaeologists must expect scientists to be partners, not servants, if they are to achieve the most satisfactory interpretations.

Analytical techniques

Current scientific work on pottery has three principal objectives. The most important is to establish the *mineral* or *chemical characteristics* of a pot or ware, in order to find out where it was made or to distinguish between similar pots made in different places. The analytical procedures employed also allow the second objective to be achieved – detailed *descriptions* of characteristic wares can be defined and published, so that subsequent finds can be compared with them. Third, scientific investigation can elucidate pottery *technology*, by giving insights into clay preparation, surface treatments and firing conditions. Archaeologists can only begin to make broad interpretations about the production, trade and economics of pottery when its composition, origins and manufacturing processes are all understood. Pottery specialists have for a long time attempted to investigate all of these objectives, and many observations can still be made without scientific analysis. However, analysis brings a greater level of precision, objectivity and reliability to the results, and it is indispensable in the many cases where the human eye is unable to detect significant differences.

Petrology
The technique of petrology (literally, the study of stone) is familiar to geologists, for it relies upon the examination under a powerful microscope of thin sections cut from sherds (fig. **15**). It is possible to identify grains of sand or fragments of stone incorporated into the clay, particularly if they come from distinctive types of volcanic rock; their likely area or region of origin can then be predicted. The success of petrology in identifying the precise locations in which minerals occur depends on the quality and extent of geological fieldwork. Fortunately, most countries included in the former Roman empire have been investigated,

15 Photograph (taken through a microscope) showing a 'thin section' cut from a sherd of Black Burnished Ware. Geologists are sometimes able to recognise distinctive minerals by their visual characteristics and thereby suggest the source of the clay. Accurate geological descriptions are now an essential requirement in any classification of Roman pottery (see fig. **19**).

although coverage around the Mediterranean is uneven. One of many examples of the successful elucidation of an archaeological question through petrology has been the precise fixing of the origin of amphorae used to transport wine from central Italy. They are made of clay from a volcanic region with a characteristic range of minerals; furthermore, the presence of one particular mineral, a yellow-brown garnet, is specifically associated with the area around Pompeii and Herculaneum. This kind of information has major implications for the interpretation of the agriculture and economy of the region.

In addition to the identification of minerals, the size, shape and frequency of grains included in the clay can usefully be recorded by *textural analysis*. Potters operating at a particular place may have added crushed stone to their clay in order to improve its working properties; comparisons of practices of this kind, combined with detailed typological study, may help to differentiate between separate production centres within a general region once this has been identified through geological characteristics.

Chemical analysis
Thin sections will include the common visible constituents of a clay, but if necessary rarer minerals or individual elements of potential significance must be identified separately by chemical analysis. This is particularly appropriate for the study of fine wares (such as terra sigillata or 'colour-coated' wares) which lack large sandy minerals identifiable by petrology, or for other pottery which has inclusions derived from common sedimentary rocks rather than distinctive volcanic sources. Various methods can be employed to establish the composition of a particular clay: for example, *neutron activation analysis* or *X-ray fluorescence*. Both share the principle that a small sample is irradiated, and that a spectrometer subsequently records radioactive emissions in order to identify and measure the chemicals or elements contained in the sample.

It is much more difficult to interpret chemical analyses than petrological thin sections, for the likely origins of a subtle blend of elements cannot be determined from geological maps. The results must be compared with reference collections of analyses of pottery and clays from *known* production centres. Kiln sites provide ideal sources of reference material, for thousands of sherds were normally discarded during manufacture because of breakages or faults. Sherds discoloured or distorted during firing can safely be assumed to be local products; so too can the clay used to make parts of the kilns themselves. When large numbers of sherds have been analysed, statistical study of the results can establish which chemical constituents are most characteristic of local clays, as well as the quantities in which they are normally found. Maurice Picon's laboratory in Lyon has compiled analyses of hundreds of sherds of terra sigillata, and statistical tests have then singled out diagnostic components which act as 'fingerprints' to distinguish between individual production centres. For example, terra sigillata made in Lyon contains around 2 per cent of potassium oxide (K_2O) and 11 to 15 per cent aluminium oxide (Al_2O_3), whereas terra sigillata from Lezoux contains $c.3.5$ per cent K_2O and 20 to 23 per cent Al_2O_3.

Terra sigillata on the German frontier – Italian or Gaulish?

Picon used X-ray fluorescence to answer a long-standing question concerning pottery supplies to Roman forts established in Germany during the brief attempt

to occupy territory between the Rhine and the Elbe between 12 BC and AD 9. It had been thought that the terra sigillata used on these sites was 'arretine' ware, manufactured primarily at Arezzo in Italy, but discrepancies between the precise forms of dies used by potters to stamp their names on products found at the kiln sites in Italy, compared with those excavated on sites in Germany, had led to suspicions that some of the pottery was made at an unknown centre elsewhere, possibly in France. Ateius was the most prolific producer from Arezzo whose firm's name-stamps caused problems and, to complicate matters further, evidence of a second production centre operated by Ateius was found at Pisa in the 1960s. Soon afterwards, 'arretine' terra sigillata production was finally confirmed in France in excavations at Lyon, an important city lying on the main route from the west Mediterranean to the northern frontiers. Picon rapidly established the chemical characteristics of local products by analysing sherds from the Lyon kilns, confirming that they were indeed the origin of much of the Ateius pottery found in Germany.

A detailed report on terra sigillata found in the fort at Haltern was published in 1982 by the director of recent excavations, Siegmar von Schnurbein. Perhaps the most significant section was written by Maurice Picon (together with Lyon archaeologist Jacques Lasfargues), incorporating his analyses of 315 terra sigillata sherds found on the site; X-ray fluorescence had been used to measure the presence and quantities of specific elements of known significance. The results were compared (using statistical techniques) with analyses of samples from ten reference collections, composed of sherds from Lyon and several production centres in Italy. When this scientific evidence for place of manufacture was integrated with potters' name-stamps of known origins, it proved possible to assess the sources which supplied terra sigillata tableware to the fort at Haltern: 48 per cent came from Lyon, and 36 per cent from Pisa; only 2 per cent actually originated in Arezzo, while a further 5 per cent came from other Italian sources. The existence of additional production centres, yet to be discovered, was implied by the remaining 9 per cent not attributable to a specific source (fig. 16).

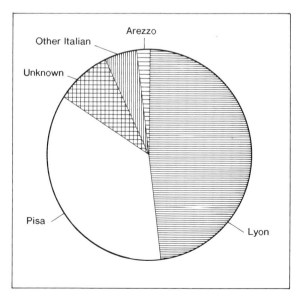

16 Pie chart of sources of tableware found at Haltern, a Roman fort in Germany. This terra sigillata was initially thought to have been made primarily at Arezzo in Italy, but scientific analysis of clay samples demonstrated that Lyon was the major source, followed by Pisa. Ideas about the logistics of supply obviously had to be rethought; one of the values of scientific analysis is that the results frequently demand a radical revision of accepted concepts.

The analyses also provided the excavator with a useful means of checking his ability to make purely visual identifications, which turned out to be reasonably accurate for Lyon products but very difficult for distinguishing between Italian sources. The presentation of von Schnurbein's report on the terra sigillata from Haltern was greatly enhanced by this knowledge: instead of a straightforward typological classification, each type of vessel could also be subdivided according to its place of manufacture. Many subtle distinctions were observed, sometimes in the details of rims or bases, sometimes in overall proportions. Interestingly, some variations of shape which most archaeologists would probably have considered significant for dating purposes actually reflected different – but contemporary – sources.

Von Schnurbein was not content simply to publish analyses and a refined typology of the terra sigillata from Haltern; this information provided considerable scope for further interpretation. He added discussions of the organisation, date and economic implications of manufacture in Lyon, and an overview of the 'Ateius problem'. His report is an excellent example of integrated scientific and archaeological research; he reviewed material excavated in the past in the light of newer finds, and Picon's extensive range of analyses was focused very precisely on a long-standing research problem about the origins of 'arretine' terra sigillata. The result was that new ideas could be presented about industrial organisation in pottery manufacturing centres and about the beginnings of the process of diffusion of terra sigillata production from Italy into Gaul.

Statistics

Archaeologists involved in the study of Roman pottery are inevitably becoming better acquainted with scientific analysis and dating; growing familiarity with the way in which scientists interpret their information has also heightened archaeologists' awareness of the usefulness of statistics. For example, comparisons of scientific analyses involve the notion of *probability*, which can usefully be applied to archaeology. Archaeologists frequently compare the relative numbers of various types of pots found on different sites in order to draw conclusions based on the extent of similarity. Statistical probability tests can reinforce such comparisons, by taking into account the size of samples and measuring the level of confidence at which apparent differences can be interpreted as meaningful, rather than simply the result of chance.

An awareness of the usefulness of scientific procedures and statistical analysis has also enhanced the desire to record finds from excavations or fieldwork with greater consistency and precision. Fortunately, this phenomenon has coincided with the introduction of microcomputers since 1970, and their spectacular increase in power (with reduction in cost) since 1980. Programs for data management and statistical analysis which were suitable only for mainframe computers in the 1960s are now readily available for microcomputers on the desks of individual pottery specialists. In chapter 5 we examine how their productivity has been revolutionised by facilities such as these.

— 5 —

Working with Roman Pottery

General Pitt Rivers, the remarkable pioneer of archaeological publication in the late nineteenth century, believed that everything found in an excavation should be recorded and published in detail, for the reason that information which did not seem significant when he found it might be important to someone else in the future. His magnificent reports on excavations in Wessex published in the 1890s actually included Roman pottery vessels, and the excellent drawings and descriptions make it possible to identify them accurately today. Unfortunately, most other excavators aimed to recover structures rather than artefacts and regarded pottery as entirely incidental; at best a few unusual or complete vessels might be illustrated. It is shown in chapter 2 how Roman pottery did not become an integral part of publications of archaeological excavations until recent decades, and that the exceptions to this rule were sites where dating was very important – notably military forts on the northern frontiers of the Roman empire.

The twentieth century's wider interest in social and economic aspects of the Roman empire stimulated a more comprehensive approach to pottery publication. Fortunately, coarse kitchen wares are now regularly published alongside amphorae, lamps, terra sigillata and other fine wares. The impact of scientific analysis and statistics has also been very beneficial; no modern excavation report on pottery is complete without detailed petrological descriptions of wares and full catalogues of the precise numbers of pots found in each excavated context. Some of the most detailed reports published in recent years have come from sites around the Mediterranean, such as Carthage and Benghazi; these are particularly instructive, because in contrast to the situation in the northern provinces of the Roman empire, little or no groundwork had been carried out on local pottery until the 1980s. But how do archaeologists actually deal with Roman pottery, both on site and after an excavation has finished (fig. **17**)?

Pottery from excavations: Carthage

The ancient city of Carthage (on the outskirts of modern Tunis) rivalled Rome for control of the western Mediterranean until the power struggle was brought to an end by the city's destruction in 146 BC. However, Carthage revived as a major

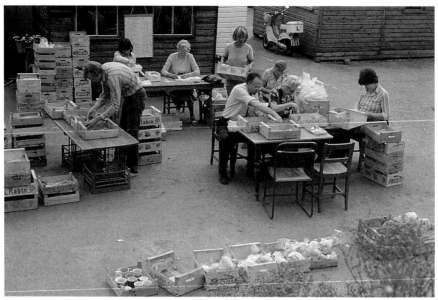

17 Pottery processing at Colchester, Essex. Excavations on Roman sites normally produce very large quantities of pottery which must be washed, sorted and catalogued in a systematic manner (see figs. **14** and **18**), supervised by an archaeologist with considerable experience and knowledge of ceramics.

port for Roman Africa and became a capital once more in AD429, when the Vandals (one of many Germanic tribes involved in the 'barbarian' migrations of the fifth century) established a kingdom there. Roman rule was restored when the Byzantine emperor Justinian brought the Vandal kingdom to an end in 533; Carthage then remained part of this Mediterranean empire until it was absorbed by the Arabs in 698.

When modern building development began to encroach upon this important site in the 1970s, an international effort was organised to carry out excavations in advance of destruction. Vast quantities of pottery have been recovered from high-quality stratigraphic excavations, and the enormous programme of publication has only recently begun. One example is the report by Michael Fulford and David Peacock: *The Avenue du President Habib Bourguiba, Salammbo: the pottery and other ceramic objects from the site*, published in 1984. It provides a vivid contrast to the pottery from the Roman fort at Haltern in Germany mentioned in chapter 3, which belonged to a precise date (7 BC–AD 9), for the Carthage site in question ranged from c. AD400–650.

Methodology
David Peacock's introduction to the Avenue Bourguiba pottery report contains an admirably clear statement of objectives and methods. In effect, he presents a modified version of the 'Pitt Rivers principle', by rejecting the ideal of total publication and concentrating instead on two specific aspects – the chronology of the site and its ceramics, and trade, both local and long-distance: '. . . it is reasonable to design a research strategy that will help answer the most pressing problems of the day, in full realisation that some questions will be unanswered and others not posed.' The details of the practical procedures which lie behind such

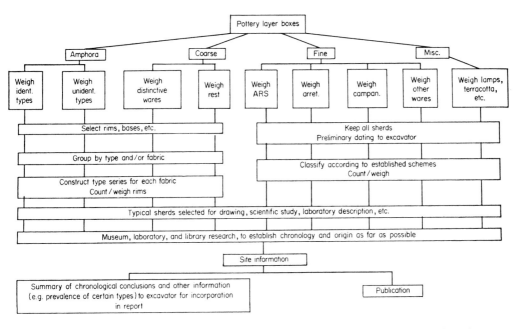

18 Diagram showing the scheme used for pottery processing at Carthage in Tunisia.

objectives are summarised in a chart (fig. **18**), which cannot convey the physical reality of the many hours of pot-washing, recording and organisation for study and storage that are actually involved in dealing with pottery from a large modern excavation.

The sherds first arrived in boxes from the excavation trenches and, after washing, were divided into four general categories which could be distinguished by assistants without detailed knowledge of Roman pottery: amphorae; fine wares (for example Red Slip Ware, the late Roman equivalent of terra sigillata tableware); coarse wares (functional kitchen and domestic vessels); and 'miscellaneous' (lamps, terracotta figurines, etc.).

Next, each of these categories was subdivided by more experienced workers into specific forms and wares, such as identifiable amphorae or African Red Slip Ware. While fine wares and lamps could be classified and dated according to existing reference works, amphorae and coarse wares had to be sorted in order to separate out diagnostic sherds, notably rims, in order to group them by form and/or fabric. Since little or nothing was known from previous work on coarse wares in the Carthage region, the diagnostic forms had to be arranged into typological order within each fabric according to their shapes; this highly skilled task was carried out by Michael Fulford. All categories were counted and weighed to provide a common basis for comparisons between different excavated contexts.

Only after all of the pottery had been classified in this way could a selection be made for drawing and scientific analysis – the enormous quantities involved made selectivity essential. Detailed research was then conducted in preparation for publication, including the important integration of conclusions drawn from the pottery with the excavator's interpretations of the contexts in which it had been found.

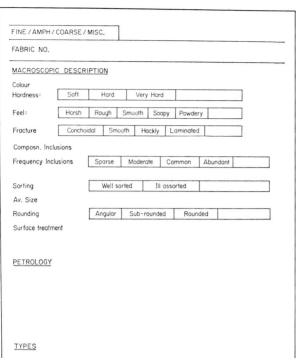

FINE / AMPH / COARSE / MISC.

FABRIC NO.

MACROSCOPIC DESCRIPTION

Colour

Hardness:	Soft	Hard	Very Hard	

Feel:	Harsh	Rough	Smooth	Soapy	Powdery	

Fracture	Conchoidal	Smooth	Hackly	Laminated	

Composn. Inclusions

Frequency Inclusions	Sparse	Moderate	Common	Abundant	

Sorting	Well sorted	Ill assorted	

Av. Size

Rounding	Angular	Sub-rounded	Rounded	

Surface treatment

PETROLOGY

TYPES

19 The Carthage scheme included detailed classification of fabrics of coarse wares and amphorae in order to group them together and, where possible, to determine their origin. This form allowed the physical and geological characteristics of wares to be recorded systematically in order to facilitate comparisons.

Classification

Not surprisingly, Peacock's report began with a definition of fabrics based on petrological analysis (fig. **19**), including suggestions as to their origins where possible, using methods described in chapter 4. An interesting exception to the usual interpretation of geological evidence was made in the case of one group of sherds containing fragments of volcanic rock from Sardinia and Italy. Instead of simply deducing that it had been imported from those sources, Peacock suggested that this pottery was made locally by potters who added volcanic sand to their clay, and that the sand was 'recycled' from crushed broken fragments of millstones known to have been imported to Carthage from Sardinia and Italy.

Next in the report comes a discussion of stratigraphy and dating evidence and of the reasons for selecting particular excavated groups of pottery for full publication. Extensive sections are dedicated to the presentation of Red Slip Wares, subdivided by area of origin and then organised according to their shapes. Fulford then tackles 'coarse' kitchen and domestic wares, set out according to their fabrics and arranged typologically – from wide open vessels such as bowls through to tall narrow flagons. Short accounts of further ceramic categories follow: lamps, building materials and terracotta figurines. Thus other specialists making a general study of any particular kind of pottery (for example Red Slip Ware from Turkey, or a type of lamp) can discover exactly what was found on the site, without having to disentangle information scattered throughout the report. All publications should ideally be organised with such a clear concept of the varied needs of readers.

Quantification

A notable feature of all sections of the report is the use of precise numbers, stating

exactly how many examples of an individual type of pottery vessel were found in each excavated group selected for publication and, in the case of common types, what percentage of the group they made up. Because of the very large quantity of pottery found on the site, numbers of vessels were estimated simply by counting rims. Had resources been greater, it would have been desirable to quantify the pottery more precisely by recording each rim sherd as a percentage of a complete pot's circumference. This allows an objective calculation of the minimum number of pots of any particular type; for example, if the total percentage comes to 750 per cent, it is obvious that the rim sherds represent at least eight complete vessels. The lifespan of the use of a form of pottery can be estimated by finding the earliest dated groups in which it first appears; its greatest popularity is reflected by the date of groups where it is found in the highest percentages. However, it is much more difficult to determine the *end* of the date-range on a complex site occupied for many centuries, because excavated deposits inevitably include residual fragments of older pottery, disturbed during activities such as construction work or the digging of ditches and pits.

In the case of amphorae, numbers could not be estimated by counting rims, for the rim constitutes only a small part of the complete vessel. Instead sherds were divided into distinctive forms and fabrics (established by petrological analysis) and then weighed; the groups selected for study produced more than 1500 kg of amphora sherds. Around 55 per cent were found to be of local North African origin and a further 20 per cent were well-known types imported from a variety of sources around the Mediterranean. The potential for further research was indicated by the fact that 25 per cent of all amphora sherds could not be assigned to any of the familiar local or imported forms. Having established the weights of amphorae in each excavated group, it was possible for Peacock to detect fluctuations in the quantities of amphorae from different sources over time. East Mediterranean amphorae, for example, displayed a clear peak in the late fifth century.

Interpretation
It was shown in chapter 4 that scientific analyses of terra sigillata from the Roman fort at Haltern opened up wide-ranging possibilities for the study of the organisation and economics of the terra sigillata industry. It is not surprising to find that even greater potential is revealed by the pottery from Carthage, a major city and port astride the Mediterranean sea-lanes. Thanks to careful stratigraphic excavation on a very large scale, Fulford was able to refer to groups of dated pottery covering nearly 150 years. Changes in the pattern of imports (particularly from the east Mediterranean) could be interpreted in relation to the known history of Carthage.

The three major categories of pottery involved (amphorae, Red Slip Ware and coarse ware) reflect overseas trade in different ways. The fact that amphorae were containers for wine, oil and other products takes their significance beyond that of other pottery, for they represent trade in agricultural produce, not in pottery. As a fine tableware, Red Slip Ware might be traded in its own right, particularly when ships laden with amphorae or grain were able to take it on as additional cargo. The coarse wares were not normally an item of trade, but they might easily be included among the possessions of seamen or traders; high percentages of imported coarse wares therefore reflect the overall intensity of contacts of all kinds. Surprisingly, the period of Vandal rule was the time of greatest diversity

and quantity of imports, whereas the Byzantine reconquest in AD 533 led to a reduction. It seems that independence from direct Roman rule brought financial benefits – thanks to the removal of demands by central government for taxes and by overseas landowners for rents – and did not disrupt trade.

Publication

In the case of Carthage, the report on pottery from the Avenue Bourguiba was sufficiently important to be published as a monograph. As Peacock noted, 'There is no doubt that, in some parts of the world where there is a good data base, much of this detail could be assigned to the archive, but this does not seem desirable in an area of research where there is still so much basic evidence to be gathered.' Future publications of excavated contexts from the same general period will be able to refer back to it, and will only need to illustrate new kinds of pottery which had not previously occurred. Specialists will still have to examine *all* of the pottery found, in order to determine the date of excavated contexts and sort out groups that are significant for the interpretation of the site. It is essential that this preliminary work should be conducted in order to know exactly what is typical and representative of the pottery from a site; this fundamental point is applicable to all excavations but is not always fully appreciated, even by their excavators. Efficient methods and procedures for sorting, identification and quantification all help to produce compact but informative publications.

Pottery from field surveys

Excavation is now so expensive and labour intensive that many archaeologists have turned to other forms of fieldwork addressed to broader questions about the Roman period. A common approach is now field survey, aimed at studying changing patterns of human settlement over wide areas; it has become particularly popular around the Mediterranean and large regional investigations have already taken place in Greece, Spain, Italy and North Africa. In areas subject to modern settlement and farming, this kind of survey work involves teams of archaeologists recording scatters of artefacts and building materials brought to the surface by ploughing or other agricultural activities. In some desert regions sites may be more obvious, with extensive visible remains. The virtual indestructibility of fired clay makes pottery an important class of find, and since pottery was used in large quantities on most sites in the Roman period, it provides an important means of both identifying and dating sites.

The Etruria Survey, Italy

Large numbers of sites were discovered in central Italy by archaeologists from the British School in Rome after extensive ploughing during the post-war expansion of arable farming. In an early example of the use of pottery for dating Roman settlement patterns, the presence of distinctive dated wares, such as terra sigillata and Red Slip Ware, was used to detect occupation at different periods. A series of maps of find-spots was drawn to illustrate the gradual expansion of settlement in the countryside from the late Bronze Age to the early medieval period. A notable peak occurred in the early Roman empire, when villas and farms occupied virtually all suitable land (fig. 20).

However, the use of pottery evidence for this purpose raises serious methodological questions. First, is it safe to assume that a representative range of

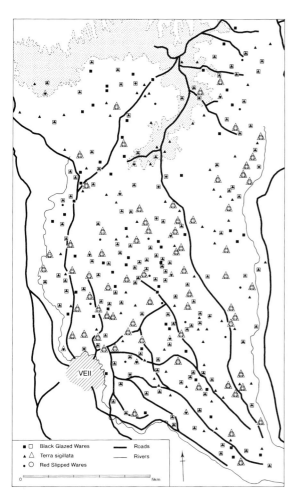

20 Pottery from fieldwork in Etruria, central Italy. Three categories of pottery of different periods are represented on this map. It is apparent that some sites were occupied in only one period, while others were inhabited throughout. The third and latest period suggests a reduction in occupation, and very few new sites were established in this phase. Patterns of this kind provide many possibilities for historical, economic and demographic interpretation.

VEII

	Black Glazed Wares	Roads
▲ △	Terra sigillata	Rivers
• ○	Red Slipped Wares	

0 5km

pottery from the entire lifespan of a site will have been turned up on to the surface by modern farming? This may well not be the case on sites where there is a deep accumulation of occupation levels, and where later deposits have protected early remains from ploughing. Second, was pottery always readily available to the occupants of all classes of site? A feature of the distribution of late Roman sites in Etruria is that large villas apparently tended to survive, while smaller farms disappeared. Was Red Slip Ware in fact much more expensive than earlier terra sigillata, so that only the wealthier inhabitants of larger sites could afford it? If this was indeed the case, then finds of Red Slip Ware may only indicate the presence of large villas, not necessarily the absence of smaller farms.

Can we even assume that scatters of pottery always represent 'sites'? Evidence from a project centred on a Roman villa at Maddle Farm in Britain suggests that domestic rubbish was normally used as fertiliser on surrounding fields. The amount of broken pottery actually left on the villa site would thus be reduced, and quite misleading concentrations of finds could turn up well away from the actual villa complex, incorrectly suggesting the presence of further settlements. Nevertheless, field survey projects have revolutionised our ideas about the

nature and extent of rural settlement in the Roman period, and finds of pottery have played a central role in examining the social and economic factors involved. Expressing uncertainties about interpretation is healthy, for it encourages us to formulate questions that force us to take a new and critical look at the data.

Libya

A recent field survey project in an area of desert has provided an opportunity to test some of the problems posed by surface collection. The UNESCO Libyan Valleys Survey encountered hundreds of sites of farms and other buildings, many of them built of stone, well preserved and unencumbered by overlying deposits. Unlike sites in Britain or Etruria which have been demolished, levelled and subsequently disturbed by ploughing, these Libyan sites offered much less opportunity for the collection of pottery. Some were subsequently excavated, and statistical tests allowed precise comparisons to be made between surface collections and excavated samples. The results were reassuring, if slightly surprising, for sherds from the surface were found to reflect the buried deposits fairly accurately.

The Libyan Valleys Survey illustrates another problem. Whereas imported amphorae, lamps and fine wares (terra sigillata or Red Slip Ware) are readily identifiable and datable, thanks to finds made over a long period all around the Mediterranean, coarse pottery is usually made relatively locally. Neither the typological development of local forms nor the petrological characteristics of their fabric can be established unless diagnostic sherds are found in stratigraphic excavations alongside datable fine wares and/or coins. It may thus be necessary to plan at least one sizable excavation as part of a field survey project. Alternatively it may be possible to track down small numbers of local pots which did travel to major sites, where they may be found in datable contexts. Thus recent detailed reports on pottery from excavations at coastal trading centres such as Carthage, Benghazi and Sabratha also help field workers studying settlement in inland areas.

The future

In Britain a series of property development booms from the 1960s to the 1980s led to the recovery of enormous quantities of Roman pottery (and many other finds) from rescue excavations. Unfortunately, the funding of these projects rarely included sufficient provision for the cost of publication to the high standards expected today. In 1980 the Department of the Environment (the government body ultimately responsible for funding rescue archaeology) felt it necessary to publish *Guidelines for the processing and publication of Roman pottery from excavations*, in an attempt to introduce standard practices for dealing with the backlog of unpublished pottery as well as new finds. In addition to dealing with fundamental questions of dating, pottery reporters were instructed to:

> ... study the distribution of pottery over the site, since it may well provide useful information on the development and function of different areas or buildings, [and] as far as possible attribute particular wares to a local factory or area of origin, and consider the pottery in terms of its local and wider contexts. This will help to elucidate the site's external trading relationships and will make available information about the marketing arrangements of pottery industries generally.

The Guidelines were distributed to directors of excavations receiving funding from the DOE. It was depressing to find that, a century after Pitt Rivers, excavators still needed to be told to collaborate with pottery specialists, to provide them with adequate information about the excavations, and to take account of the implications of their pottery report in the final publication.

In the 1990s, publication costs have forced many excavators to abandon the 'traditional' excavation report published in book form. Some produce series of separate reports ('fascicules') on specific subjects, particularly where many small excavations take place in a large site such as a town. Thus the York Archaeological Trust has planned twenty volumes of reports on its many excavations, and each volume will consist of many separate parts; four fascicules of volume 16 (pottery) had been published by the end of 1990. The size (and cost) of printed books can also be reduced by publishing selected information on microfiche instead of printed pages. Up to 98 pages can be included on a single microfiche measuring 15 by 9 cm, but the reader must have access to suitable equipment to be able to read them, and photocopying is difficult.

Other excavation directors are abandoning printed reports altogether; instead they aim to compile full archives on their sites and finds, which can be consulted on demand. The computer revolution described at the end of chapter 4 is making this easier every year; new forms of data storage such as laser-disks allow text, drawings, still photographs and even sequences of 'film' to be recorded and retrieved by microcomputer. However, it must be stressed that neither archives nor laser-disks reduce the amount of work involved in preparing a proper pottery report. Stored archives and disks also deprive pottery specialists of the irreplaceable feeling of satisfaction (and potential career advancement) to be gained from seeing their work included in a substantial and impressive book on a library shelf. Indeed, other specialists may never get to know about the existence of important new finds if they are not published in book form.

In 1991 the DOE (through English Heritage) published a further report, *The current state of Romano-British pottery studies*, which reviewed the previous twenty years' work. It includes managerial concepts of targets and rewards, and reflects the philosophy of disengagement of central government from local issues that characterised other areas of British politics in the 1980s. As for many other activities formerly funded from public sources, English Heritage would like to see a situation where commercial developers pick up the bill for pottery processing, leaving itself free 'to move away from the site-by-site approach and to embark upon more broadly-based synthetic projects'. It is difficult to imagine developers being persuaded to spend large sums of money on the fundamental but unglamorous process of dealing with excavated pottery, in addition to funding rescue excavations, which do at least have public relations value.

The 1991 report makes sensible recommendations for standards of recording: in essence, 'a written summary of the pottery present with basic quantification and a discussion of date(s) would represent a minimum'. Unfortunately, it detects 'a lack of experienced, clear-thinking practitioners among those reporting on Roman pottery, who can estimate their work programmes accurately and work to schedule'. If this is true, then who is going to conduct the primary processing upon which reliable 'broadly-based synthetic projects' are based? And if the prospects are so poor in Britain, what hope is there for progress in those areas of the Roman empire which now form parts of poorer countries in Europe and around the Mediterranean?

— 6 —

Pottery Production and Technology

Our knowledge of Roman pottery manufacture is based primarily on the study of excavated kiln sites and examination of the characteristics of pottery vessels. A further source of valuable information is the observation of techniques still in use today among potters employing traditional methods, which reveal not only the technology involved but also the organisation of the work.

These kinds of studies have shown that the scale of Roman pottery production could range from a part-time activity which supplemented farming to full-time employment for specialised craft workers. The standardisation and wide distribution of many wares suggest that most pottery was made commercially, rather than for the home consumption of individual households or estates. Diversity of production was common; the major centre for the manufacture of terra sigillata at Lezoux in central Gaul was part of a large region containing many other sites, at which were made various combinations of coarse wares, colour-coated or glazed fine wares, terra sigillata, tiles and moulded figurines (fig. 22). We do not know of any technical innovations in Roman pottery production but 'technology transfer' took place rapidly and widely, so that provincial potters from Britain to Africa were able to produce terra sigillata and other fine wares of Mediterranean design which, in the absence of patents, drove successive Italian and Gaulish products from the market.

Forming by wheel and by hand

Wheel-throwing had already been known for several thousand years around the Mediterranean and was in use in Britain at least a century before the Roman conquest. The precise form of the Roman potters' wheel is not known, but finds from production sites suggest that it was powered by kicking and maintained an even rotation by means of a heavy stone flywheel. The regularity of Roman rims and vessel profiles indicates that most pots were made on a wheel, an impression confirmed by close examination of the interior surface of sherds, which frequently bear distinct horizontal lines or ridges left by the potter's fingers as the pot rotated (fig. 21).

Not all Roman pots were wheel-thrown, however; simple hand-built vessels were still produced in very large quantities and achieved wide distribution.

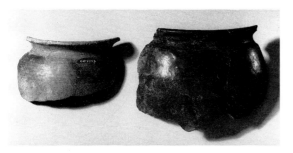

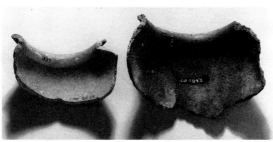

21 Black Burnished Ware sherds illustrate differences between wheel-thrown and hand-built vessels. The cooking pot rim on the left is a wheel-thrown imitation of the handmade vessel on the right; the contrast is more obvious on the interior surface, which is much smoother and more evenly formed on the wheel-thrown example (*bottom left*).

Romano-British Black Burnished Ware is the best example, but this simple technology was by no means limited to the fringes of the empire, for bowls and lids made in the same way on the island of Pantelleria (between Sicily and Tunisia) reached Sardinia, Italy and the North African coast as far south as Libya. It is not always easy to distinguish hand-built vessels from their wheel-thrown counterparts; sherds from the wall are more likely to reveal the method of manufacture than is the rim. Since most hand-built pots were made by the coil technique, the interior surface is usually rather uneven, showing signs of the pressure applied in order to join the coils and make the walls thinner either by hand or with simple tools (fig. **21**). Observation of modern traditional potters suggests that this was probably done on a small pivoted wooden turntable which could be rotated to produce a more even profile and regular thickness (fig. **26**).

Some standardised and mass-produced pottery vessels (such as plain terra sigillata plates or open bowls) may have been made by using a lathe-turned wooden blank to form the precise shape of the inside of the vessel. It would have been centred on a potter's wheel and a measured quantity of clay placed over it; the exterior profile would be formed by holding a template against the surface while the wheel rotated. There is no direct evidence for this method of production, but it is difficult to conceive of any other method of achieving the remarkable standardisation of terra sigillata. Statistical studies of dimensions and weights have underlined the high precision of standardised production in Roman tableware industries.

Decoration

Many techniques of surface treatment are available to potters. A finished pot (whether hand-built or wheel-thrown) can be smoothed with hand strokes or a sponge while still damp, or burnished with a smooth hard tool when it has dried. Simple decoration can be added in the form of grooves or ridges. None of these effects are of any great significance from a technical point of view, for they do not

reveal any complexity that might give insights into the organisation of production. Fortunately, a sizable proportion of Roman pottery is rather more elaborate, and potters selected many different ways to enrich their products that go beyond purely functional necessity.

Quite apart from technology, the choice of decoration presumably reflects the tastes of consumers. Scenes from classical mythology abound on terra sigillata, while Christian motifs appear on the later Red Slip Wares. More earthly concerns include hunting, gladiatorial combat and erotic scenes or symbols. The use of name-stamps reveals basic literacy in large workshops, while phrases including exhortations to drink and be merry, found on beakers made in the Mosel region of Germany in the second to third centuries AD ('motto-beakers'), imply a widespread acceptance of Latin in the western provinces among purchasers whose social level need not have been particularly high.

Slips and glazes

It has already been observed in chapter 1 that the decorative repertoire of Roman pottery included many surface treatments inherited from earlier Greek ceramics. The most important was the *slip*, usually achieved by dipping an unfired vessel into a diluted liquid clay to cover the entire surface with a coating of fine particles. Some slips contained minerals which, once fired, produced a glossy fused surface. Mosel motto-beakers and contemporary drinking vessels from the central Gaulish terra sigillata workshops have remarkably fine black fused slips with a lustrous metallic sheen identical to the surface of terra sigillata, but deliberately fired in a reducing kiln atmosphere (lacking in oxygen) to prevent the normal red coloration.

Painted slip decoration was particularly common on late Roman pottery; red tablewares and dark brown or black beakers frequently bore contrasting white designs. Many bowls, mortaria and flagons were made in a white iron-free clay and decorated with painted patterns in dark red or brown slip (fig. 22). Examples of both can be found among the products of the Oxford and New Forest industries in Britain, while the dark-on-light technique has also been encountered on pottery of the fifth to sixth centuries AD excavated at Carthage in Tunisia. In contrast, true vitreous glazes were never common (unlike in the medieval period); they occur sporadically throughout the empire at different dates, and are usually found on drinking and table vessels.

Moulded, applied and stamped designs

Many Roman vessels were made with surfaces decorated using techniques suited to mass production. The study of moulds and their products shows that two techniques were used for moulded decoration. *Relief* moulds were used widely in terra sigillata production. They were in effect clay bowls, with individual hand-held decorative motifs pressed into their interior surfaces before firing, while the clay was still soft. The mould was placed on a wheel and clay was pressed into it so that the decoration would stand out in low relief on the vessel; the interior surface was smoothed and a rim was formed by hand. *Applied* decoration consisted of figures, leaves or similar motifs made in small moulds and stuck on to the surface of a vessel before it was fired (fig. 22). Other vessels might be thrown free-hand on a wheel and then decorated with individually stamped motifs.

North African Red Slip Ware was often embellished with stamps or appliqués; decorated terra sigillata was almost exclusively made in moulds, but late

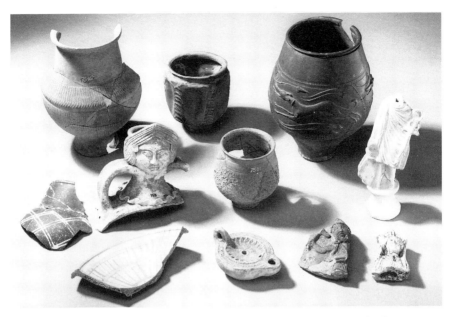

22 A selection of vessels and sherds from the Roman fort and town at Corbridge, Northumberland, illustrating a wide variety of methods of decoration and surface finish (see cover illustration). The techniques include coloured slips (*back centre* and *right*), painted slip decoration (*front left*), moulding (*bottom centre* and *right*) and modelling by hand (flagon with face mask). The four beakers are typical of Roman fine wares, and their decoration illustrates 'barbotine' slip-trailing (*right*), 'roughcast' clay particles (*centre*), indentation (*back centre*) and 'rouletting' (*left*).

Italian plain forms frequently bore small applied motifs on their rims. Stamped decoration became particularly common in the northern provinces, as well as in Spain and around the Mediterranean, in the late Roman period; this presumably reflects the decentralisation of production. The use of stamps or appliqués did not involve such specialised technical skills as the relief-moulding of entire bowls, and therefore suggests a lower level of manufacturing sophistication.

Examination of collections of Roman pottery shows that the most versatile form of decoration found throughout the Roman empire did not employ repetitive moulds or stamps at all. Soft clay was piped, trailed or pressed by hand on to the surface of unfired pots in exactly the manner used today for decorating iced cakes. Simple lines, blobs or scrolls were fairly easy to execute, but with more skill complex animals and figures could also be produced (fig. **22**). This technique (known as *barbotine*) was used on a range of pottery from coarse wares to terra sigillata but was most common on fine drinking vessels, where it was enhanced by a slip or glaze. The energy and technical diversity devoted to the decoration of pottery underline the complexity of ceramic industries in the Roman empire and clearly suggest that consumers had a real choice between competing wares.

Firing

Most of our knowledge of Roman kilns comes from the excavation of surviving structures, but this favours the more substantial and complex permanent structures. We know from ethnographic studies that many handmade pots were fired

23 Reconstruction drawing of a Roman kiln. In this example, the firing chamber contains pipes to protect terra sigillata vessels from direct heat and smoke from the fire; kilns for ordinary pottery dispensed with this feature. The reconstruction is based on the excavated example at Rheinzabern, Germany, illustrated in fig. **24**.

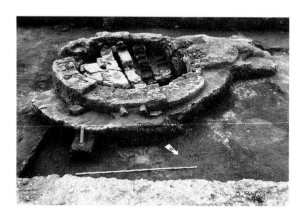

24 Kiln excavated at the east Gaulish terra sigillata manufacturing centre at Rheinzabern. The firing chamber has a diameter of almost three metres, and contains supports for a clay floor. The fire was lit in an arched flue (*right*) more than three metres long (see fig. **23**).

in bonfires, rather than kilns; although surprisingly effective, this technique produces colour variations which would not be acceptable on quality tablewares. Bonfire firing is almost impossible for archaeologists to detect, for it leaves only a large burnt area and a few broken pots. Simple kilns can also be difficult to locate, for some potters employed reusable clay bars to construct a platform on which pots were stacked and fired, covered by turf rather than clay. The only detectable traces suggesting this kind of operation to excavators are small burnt patches associated with discarded, over-fired vessels or broken kiln fittings. Fortunately, most larger-scale production centres used much more substantial permanent kilns which are easily recognised. They consist of a round or rectangular firing chamber and a flue leading from a stokehole (figs. **23**–**4**). The floor of the firing chamber was pierced by large holes, or constructed from individual clay bars, to allow hot air to rise evenly through the interior of the chamber.

Kilns used in the production of terra sigillata were very large and included prefabricated clay pipes which conveyed heat through the load without spoiling its finish by direct contact with smoke from the fire. We know that in southern Gaul terra sigillata kiln firings were conducted by specialists on behalf of many potters. The evidence for this comes from 'tallies' scratched on plates in cursive script, recording details of individual kiln-loads. These have been found on several production sites and they tabulate the size, form and number of pots in a kiln, together with the names of the potters' workshops that made them (fig. **25**). The numbers of vessels add up to tens of thousands, reflecting the large scale of these operations as well as the responsibility placed upon the kiln supervisor. Firing specialists were not infallible; blocks of terra sigillata vessels fused together by excessive heat have been found at several sites. Potters' stamps and distinctive

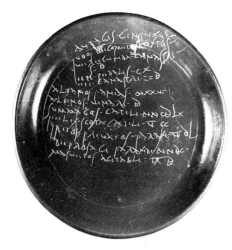

25 List of potters and vessel forms recorded by a kiln supervisor at the south Gaulish terra sigillata manufacturing centre at La Graufesenque in France. The list was inscribed on an unfired plate in cursive script and placed in the kiln. Most lines include a potter, the name of a type of vessel and a number; for example, the first two long lines read *ALBANOS – PANIAS – MXXV* and *ALBANOS – VINARI – D*. The total number of vessels fired in the kiln was 27,945, a vivid reminder of the enormous scale of terra sigillata production.

decoration on these fused 'wasters' provide valuable evidence for the contemporaneity of workshops and the artisans who stamped their products.

The interpretation of kiln sites

Pottery kilns are easily recognised, even by non-specialists, and are known throughout the empire. A kiln cannot exist in isolation, however; many other activities would have taken place on the same site: clay preparation, potting, drying, etc. – although it is not so easy to recognise traces of these activities. Careful area excavation can reveal wells, water tanks, clay pits, buildings where potting probably took place and drying sheds; potters' tools and parts of wheels have also been recognised on some sites. Very large quantities of imperfect pottery discarded during production may be recovered, and systematic recording and quantification is necessary in order to gain an accurate impression of a site's output.

Kilns did not last indefinitely and, when abandoned, their chambers and stokeholes formed useful rubbish pits for the disposal of waste products from other kilns. Thus it is very important that archaeologists do not make the mistake of assuming that all broken pottery found in a disused kiln represents the forms actually made in it, for the sherds could have accumulated over a long period and have come from several nearby kilns. Exceptionally, a firing went so disastrously wrong that the kiln was abandoned with its deformed contents still in place; only in these circumstances can the finds safely be accepted as contemporary products. Debris from kiln sites can be used to provide a general guide to the output of a particular industry, but the date and distribution of its products need to be established by studying finds found in significant stratigraphic contexts in excavations elsewhere. This is, of course, how Ritterling used finds made at historically dated forts in Germany to work out the chronology of terra sigillata made in southern Gaul (see p. 20–21).

Kiln sites provide excellent samples for scientific analysis to establish accurate petrological and chemical characteristics of the clays used in pottery production. The origins of sherds found on excavated sites elsewhere can then be checked against these reference analyses, although it must be remembered that the composition of excavated sherds can sometimes be altered by the context in which

26 This manner of making earthenware by hand, photographed in Bosnia in Yugoslavia in 1987, may not survive the civil unrest of the 1990s; thus even very recent ethnographic observations can rapidly become historical records. The potter is using a wooden turntable to rotate a vessel built up from coils of clay. Since this technique (along with the practice of firing finished pottery in bonfires rather than kilns) is analogous to Romano-British Black Burnished Ware, archaeologists can gain interesting ideas about social and economic aspects of Roman production from observation of such modern potters.

they have been buried. Scientific study can also reveal the temperature and atmospheric conditions undergone by pottery during firing, and thus help archaeologists understand the technicalities of kiln operation. For example, terra sigillata was fired in an oxygen-rich ('oxidising') atmosphere, which caused the iron oxides in the clay to become red; the temperature had to reach c. 1000 °C to ensure that the fine coating of slip fused to produce a glossy surface. Grey or black pottery was made in kilns where oxygen was restricted by sealing the flue in the later stages of firing, to create a 'reducing' atmosphere. Many archaeologists have co-operated with potters to build simulations of Roman kilns and make scientific records during experimental firings.

Ethnoarchaeology

Archaeologists use ethnoarchaeological investigations as an additional source of information for the interpretation of Roman pottery in two distinct ways. First, personal observation of pottery production, including conversations with working potters, can increase understanding of the techniques involved and heighten awareness of the possible interpretations of features or artefacts discovered during excavations. Second, fieldwork of this kind can explore the wider context of pottery production, including the social position and relationships of the potters, as well as the economics of marketing their wares (fig. **26**).

Like all ethnoarchaeology, observations of traditional potters must be used with care: why has a particular form of production survived into the latter part of the twentieth century, and how has it been influenced by the industrialisation of other sectors of the economy? How typical is it of past manufacturing methods, and how much can it tell us that is useful about the Roman period? The title of David Peacock's general survey, *Pottery in the Roman world: an ethnoarchaeological approach* (1982), demonstrates that the answer to this question can be positive. Furthermore, this approach allows us to pose questions about economics that could not easily be framed in any other way, given the dearth of references to pottery in Roman written sources; some of these questions will be examined further in chapter 7.

— 7 —

The Economics of Roman Pottery

Many of the interpretations drawn from pottery that are discussed in this book have more or less direct implications for the Roman economy. However, the study of ancient economics is more complex than might be expected and requires a knowledge of the methods used by anthropologists and economists as well as help from statistical techniques used by geographers and social scientists. The most promising lines of enquiry relate to production and distribution, but interesting socioeconomic information can also be derived from investigating the ways pottery was actually used on sites.

Modes of production

In *Pottery in the Roman world* (1982), David Peacock formulates a series of theoretical models for the settings in which pottery *might* have been made; the models are derived from a mixture of economic theory, history and anthropology. He then examines modern examples of each mode from an ethnographic standpoint, and finally attempts to fit the various known forms of Roman pottery manufacture into these predefined modes. This approach – model-building, investigation through analogy and finally testing against the archaeological evidence – is admirably scientific. It contrasts with the traditional tendency of classical archaeologists to prejudge evidence from the perspective of their knowledge of the ancient world, gained largely from limited ancient literary sources which embody the biases of the literate élite of the Roman empire. There is always a danger of missing out on equally plausible interpretations that might have emerged if a broader range of possibilities had been considered. However, the model-building approach has dangers, too, for it is impossible to devise objective models. Like anthropologists, archaeologists cannot escape personal biases when observing societies, and can be trapped into circular arguments when testing their own interpretations against hypothetical models they have themselves generated.

From domestic production to industry
The evolutionary view of typology which developed in the nineteenth century still leads many archaeologists to regard simple artefacts made by hand without

technical equipment as 'primitive', and unlikely to have been of much significance in a complex society such as the Roman empire – except perhaps among 'natives' in fringe provinces. However, Roman pottery demonstrates that low-technology products could indeed exist alongside elaborate ceramics. The bowls and lids made by hand on the Mediterranean island of Pantelleria (see p. 49) are just one of many possible examples of products of a 'household industry'. They have been interpreted as a form of primarily domestic pottery that was also made for wider sale by farming households in order to gain additional income; production need only have been a seasonal activity.

One of the most thoroughly researched types of handmade pottery, Romano-British Black Burnished Ware, proves that 'low' technology was not a limiting factor in the scale of production. Black Burnished Ware began as indigenous pre-Roman domestic pottery in Hampshire and Dorset, but in the second century AD production had expanded sufficiently to supply kitchen wares to soldiers on the frontiers over 500 km away – without potters' wheels and permanent kilns replacing hand-forming and bonfire firing. We know this thanks to the typology and dating of Black Burnished pottery found on Hadrian's Wall, and because scientific analyses of hundreds of sherds found distinctive minerals that occur in Dorset, where evidence for bonfire firings has now been recognised. Most archaeologists place too much stress on typology and technique; users who purchased Black Burnished Ware or Pantellerian pottery were not interested in its technology, but the fact that the sand in its clay made it particularly resistant to sudden heat during cooking (fig. 15).

In the absence of any direct documentary evidence, the economic interpretation of the Black Burnished Ware industry is of course purely hypothetical. My personal view (based on economic anthropology *and* Roman literature) is that owners of large agricultural estates in Dorset might have encouraged some local people to become potters rather than simply peasant farmers. The wares could then have been sold, along with foodstuffs and other supplies from the same estates, to merchants involved in supplying the army, who would have organised the transport and distribution of the pottery by land or sea. Estate managers could use pottery production to fill gaps in the agricultural calendar with labour-intensive tasks such as digging and preparing clay and gathering fuel.

The organisation of production

There is little or no evidence for the way in which pottery production was actually organised, since virtually no written records survive; we must make deductions from the pottery itself. The complexity of terra sigillata manufacture from raw clay to fired vessel, combined with the vast quantities made by workshops in Italy, Gaul and Germany, implies considerable division of labour within workshops. Furthermore, parts of the process involved skills which could have given scope for independent specialists to work for a number of workshops. We are able to avoid pure speculation, thanks to the fact that the majority of terra sigillata vessels bear name-stamps (fig. 27); the immense number of potters' names makes it clear that the industry was subdivided into many small units employing a few workers, rather than being dominated by large 'factories'. Many of the Augustan stamps found at Arezzo in Italy bear pairs of names, one a Roman citizen who is presumed to have owned the workshop, and the other (commonly Greek) probably that of a skilled slave who actually did or supervised the work. A

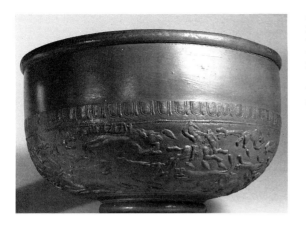

27 Terra sigillata bowl (form 37) with moulded decoration including the name of the workshop of the potter Paternus, who worked at Lezoux in central France in the mid-second century AD. Although this large 'advertisement stamp' was clearly intended to be seen, most stamps were very small and placed on the inside of the vessel.

recent study found that 110 workshops are known; the number of slaves associated with a single owner's name is typically between ten and twenty, but ranges from only one up to sixty-five. We know from potters' stamps, kiln sites and scientific analysis that one notable workshop owner, Cnaius Ateius, ran several manufacturing operations in both Italy and Gaul during the reign of Augustus.

The Gaulish terra sigillata workshops of the first and second centuries AD were smaller and more numerous than those of Italy and include many owners' names of native Gaulish origin. Stamps on plain vessels frequently take the form oᛏ.IUSTI or ALBVCI.O}, incorporating *officina*, the Latin term for workshop, and the name of its proprietor; individual workers are indicated by stamps such as LABIO FECIT, meaning 'Labio made this', or PONTI.MAN, 'made by the hand of Pontus'. Many moulds for decorated bowls incorporated large 'advertisement' stamps into the design, carrying the name of the workshop owner rather than the maker of the mould or bowl (fig. 27). Mould-makers often wrote their names freehand in the damp clay of a mould before it was fired; it is apparent that these signatures were only intended to identify the mould during firing or use, for they were normally obscured on finished bowls by the addition of the footring. In theory, a single mould-decorated bowl might preserve the mould-maker's name (freehand and backwards), a workshop name (in the decoration) and a bowl-finisher's name (on the rim or inside the base).

Information derived from name-stamps reinforces the impression that the terra sigillata industry was very large and complicated, and we must remember that many workers must also have been engaged in activities such as clay preparation that gave no opportunity to record their names. Potters' name-stamps are rare on African Red Slip Ware and virtually absent from other late Roman derivatives of terra sigillata. It would seem that the gradual diffusion and decentralisation of production led to industries too small to require a system of name-stamps to differentiate the output of workers or workshops.

The detailed investigation of terra sigillata through typology, scientific analysis and name-stamps has given us an extraordinarily detailed picture of the organisation of one Roman industry. The results are even more remarkable in the light of the almost total silence of Roman writers on the subject of pottery production. Terra sigillata production is only one end of a spectrum; simple handmade pottery is equally informative, demonstrating that pottery of all kinds can help to advance our overall understanding of the Roman economy.

Trade

Historians argue (by analogy with more recent periods with better documentary evidence) that pottery played an insignificant part in Roman trade when compared to foodstuffs or textiles. However, it is still easy to justify the study of pottery; unlike these perishable goods, it has the unparalleled advantage of survival in large quantities. Even if we cannot claim that pottery was a major trade item, its distribution is nevertheless likely to reflect patterns of commerce in other goods. The interpretation of written evidence for trade in products such as grain or wool should not be treated as anything more than one 'model', to be tested alongside others derived from economics and anthropology. It must not be forgotten that economic anthropologists have defined a series of alternatives to the marketing systems of the modern world, including some forms of exchange that involve ceremonial gift-giving rather than buying and selling.

The distribution patterns of even the simplest wares suggest that Roman pottery was normally traded, rather than used primarily in the households of its makers. The fact that the Roman empire possessed an advanced system of coinage suited to small-scale transactions must have encouraged production for sale, rather than reciprocal exchange; most peasant farmers needed money to pay rents and taxes, and their surpluses could be sold in markets for cash which could also be used to purchase items such as pottery. Many kilns must have been located on the land of villas, whose owners or estate managers would have had access to widespread markets through their ownership of carts and pack animals. Further favourable factors were the generally peaceful condition of most of the empire, an excellent road system and the proximity of the Mediterranean provinces to busy maritime trade routes. The extent of trade in Roman pottery, even in remote rural areas well away from towns, contrasts with the restricted distributions of ceramics in medieval Europe, when security, communications and coinage were all inferior.

Pots as containers
Different categories of pottery must be examined very carefully if valid interpretations are to be made about trade. For instance, amphorae are very interesting vessels which have been subjected to almost as much typological and scientific research as terra sigillata, and whose distributions have been extensively mapped. Nevertheless, it must be remembered that what is being studied is not trade in pottery, but in its perishable *contents* (notably wine, oil or fish sauce – we know what was transported in most types of amphora thanks to the ink inscriptions recording their contents which occasionally survive). One recent excavation report from Colchester underlined this fact very effectively by summarising finds of amphorae in terms of the volume of their original contents: 1619 litres of wine, 240 litres of *defrutum* syrup, 1393 litres of olive oil and 353 litres of salted fish products. It is entirely fortuitous that amphorae were made of fired clay, a material that survives well; we know that equally important foodstuffs were carried in barrels or sacks, which have decayed completely in the normal conditions found on sites or shipwrecks.

'Piggy-back' trade
Other kinds of pottery seem to have been traded not because of any distinctive qualities of their own, but because large-scale trade in other items already took

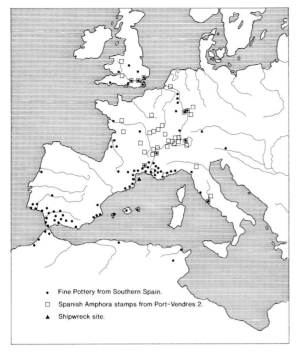

28 The distribution map is an important tool in the interpretation of pottery. This map shows amphorae from a group of southern Spanish olive oil producers whose name stamps were found together in a shipwreck off the coast of south-western France; finds of the same stamps on sites demonstrate their export markets. The map also shows finds of fine cups and beakers made in the same part of Spain; their distribution patterns coincide, suggesting that the drinking vessels were exported through the same trade network as olive oil.

• Fine Pottery from Southern Spain.

☐ Spanish Amphora stamps from Port-Vendres 2.

▲ Shipwreck site.

place from their production centres. For example, fine cups and beakers decorated with delicate plant motifs and coated with a lustrous golden slip were made in southern Spain in the first century AD. Although they mainly reached sites in Spain itself and around the coast of the west Mediterranean, they also appear widely but in very small quantities in Gaul, Britain and Germany (fig. 28). Significantly, we know from kiln sites and potters' stamps that southern Spain was the source of globular amphorae of Dressel form 20, in which olive oil was exported in enormous quantities to the same areas where these drinking vessels are found. Small quantities of fine pottery could have travelled with the amphorae without incurring heavy travel costs; perhaps oil merchants included the occasional crate to fill a gap in a cargo, in the knowledge that there was a market for drinking vessels.

It could not be argued that any serious trade in Spanish fine ware existed on its own; very small quantities were involved, and comparable vessels were readily available from many other centres. In the same way, metal exploitation in the Massif Central may have helped to ensure the success of terra sigillata from southern Gaul in the first century AD, thanks to the existence of a ready-made network of roads and rivers for transporting metal to the rest of Gaul and the armies of the Rhine. In later centuries, the importance of North African grain, wine and oil exports was undoubtedly of great assistance to trade in African Red Slip tableware.

Pottery merchants
Although helped by 'piggy-back' trading, pottery such as terra sigillata and Red Slip Ware did, of course, achieve large-scale exports because of its intrinsic qualities. It is inconceivable that each of the hundreds of terra sigillata workshops traded separately, since archaeological finds demonstrate that their products are

evenly distributed, rather than being concentrated in limited areas. Contemporary written sources about Roman trade suggest that transport, distribution and marketing were the concern of independent merchants, not potters. The Latin term for a trader was *negotiator*, and some inscriptions actually record the existence of pottery merchants (*negotiatores cretarii*; fig. **29**); an altar from the mouth of the Rhine refers to an individual as *negotiator cretarius Britannicianus* – trader in pottery with Britain. Even if *negotiatores cretarii* followed the usual practice of mixing cargoes, pottery was evidently their primary commodity. We know from literary sources that negotiatores were fairly large-scale traders who must have arranged a network of merchants, sailors and river-boatmen, as well as organising the financial aspects of trading ventures. It is difficult to imagine any other means by which large-scale export of pottery could have been achieved, considering the degree of subdivision of most industries and the dispersed rural locations of many production areas.

The general uniformity of pottery found on civilian and military sites implies that both relied on negotiatores in similar ways. The army was always an attractive market, for soldiers were well paid in cash. We have already seen that in Britain Black Burnished Ware cooking pottery used extensively by the Roman army on Hadrian's Wall came from Dorset, far away from the northern frontiers. The production area was near the coast, and negotiatores may have conducted a variety of trading activities around the western coastal seaways. Grain, textiles and pottery might have travelled northwards, while southbound cargoes could have included hides, metal ingots and slaves. The same ships may perhaps have made three-way voyages bringing wine, salt and fish sauce across the Channel from north-western France. Fragments of Romano-British pottery found all along the coast of northern Europe from Brittany to Frisia are mute reminders of the busy marine traffic that ultimately proved an irresistible temptation to pirates.

29 This altar was dedicated to a local god and Mercury in a shrine at Bonn in Germany by a *negotiator cretarius* (dealer in pottery). Despite its variety and widespread distribution, pottery hardly ever appears in written evidence about trade, unlike agricultural products or textiles. Thus it seems certain that ceramics were comparatively insignificant in economic terms, and that their producers were of low social status.

30 Specialised roof tiles, bricks, pipes and other architectural ceramics were used on an enormous scale in the Roman world. Manufacturers' name stamps were common, whether they were civilian producers or, in the examples from Corbridge illustrated here, military tileries. The square brick and curved tile both bear stamps of LEG VI V, indicating that they were made by craftsmen belonging to the Sixth Legion Victrix. Scientific analysis could tell us whether they were made from local clay at Corbridge, or brought from the legion's base at York.

Conclusions

The general absence of pottery from Roman literary sources underlines the importance of archaeology in extending our understanding of the economy (fig. **30**). The wide geographical distribution of wares such as terra sigillata and African Red Slip Ware is matched by the social range of sites which they reached. The quantities involved are staggering: virtually every Roman site in Europe occupied in the first century AD received at least some terra sigillata from southern Gaul. Hugo Blake, a specialist in medieval ceramics in Italy commenting on Roman pottery, concluded that:

> Ancient historians need to look again at their scanty sources to see how their view of society and its attitudes can be modified to accommodate the dynamic economic structure implied by the study of pottery . . . the ceramic structure (in terms of qualities and distribution) is unparalleled until the eighteenth century when the social structure of wealth and aspirations was remarkably similar to that portrayed in the Roman empire.

Blake's remarks could be widened to embrace the importance of Roman pottery studies in the broad study of the everyday life of the Roman empire, rather than economics alone. Modern techniques of ceramic research and the increasing sophistication of the results certainly justify the careful observations made over several generations by archaeologists of many nationalities who have dedicated their careers to elucidating the dates, origins, distributions and technology of Roman pottery.

Further Reading

This section includes a selection of works that have *not* already been cited in detail in the main text. Methods of excavation and the study of finds are explained in my book *Archaeology: an introduction* (London 1990). Interesting papers on the anthropological background can be found in *Ceramics and Man*, edited by F. R. Matson (London 1966) and *The many dimensions of pottery*, edited by S. van der Leeuw and A. Pritchard (Amsterdam 1984). R. Charleston's *Roman pottery* (London 1955) includes good photographs of many kinds of vessels, and a general typology has been attempted by M. Beltran Lloris, *Ceramica romana: tipologia y clasificacion* (Zaragoza 1977). Comprehensive surveys of forms and decorations make up *Atlante delle forme ceramiche 1* and *2* (*Enciclopedia dell'arte antica classica e orientale*, Rome 1981, 1985).

Terra sigillata
Terra sigillata is introduced clearly in *Arretine and samian pottery* by C. M. Johns (London 1971); manufacturing techniques are explained in M. Picon's *Introduction à l'étude technique des céramiques sigillées de Lezoux* (Dijon 1973), and recent research in France is explored in depth in *La terre sigillée gallo-romaine: lieux de production du haut-empire*, edited by C. Bémont and J.-P. Jacob (Paris 1986). Italian forms are dated and classified in *Conspectus formarum terrae sigillatae italico modo confectae*, edited by E. Ettlinger (Bonn 1990), while S. von Schnurbein's *Die unverzierte terra sigillata aus Haltern* (Münster 1982) is an excellent site report. Interesting terra sigillata and imitations of African Red Slip Ware made in Spain are presented in *Les céramiques sigillées hispaniques: contribution à l'histoire économique de la péninsule ibérique sous l'empire romain* by F. Mayet (Paris 1984).

Fine wares, amphorae and mortaria
Fine wares of the first century AD from the western provinces are the subject of my *Report on the excavations at Usk 1965-1976: the pre-Flavian fine wares* (Cardiff 1979), and a typical late Roman fine ware industry is surveyed in M. G. Fulford's *New Forest Roman pottery manufacture and distribution, with a corpus of the pottery types* (British Archaeological Reports 17, Oxford 1975). Many volumes have been devoted to amphora studies, for example *Amphores romaines et histoire économique* (Ecole Française de Rome 1989); amphorae are placed in the context of transport and agriculture by A. J. Parker in 'Classical antiquity: the maritime dimension' (*Antiquity* 64, 1990, pp. 335–46) and D. Manacorda in 'The Ager Cosanus and the production of the amphorae of Sestius' (*Journal of Roman Studies* 68, 1978, pp. 122–31). An important site report is P. R. Sealey's *Amphoras from the 1970 excavations at Colchester Sheepen* (British Archaeological Reports 142, Oxford 1985). Mortaria are mainly to be found in site reports, but trade is discussed in 'La diffusion des mortiers, tuiles et autres produits en provenance des fabriques italiennes' by K. F. Hartley (*Cahiers d'archéologie subaquatique* 2, 1973, pp. 49–60).

Coarse wares, lamps and ceramics in architecture
Other 'coarse' wares are difficult to survey in general, but see M. Vegas, *Ceramica comun romana del mediterraneo occidental* (Barcelona 1973) for one attempt. They normally appear in regional studies, for example *Types of Roman coarse pottery vessels in northern Britain* by J. P. Gillam (Newcastle upon Tyne 1970) or R. Pollard's *The Roman pottery of Kent* (Maidstone 1988), and in site reports such as S. L. Dyson's *Cosa: the utilitarian pottery* (American Academy in Rome 1976) or *Excavations at Sabratha 1948-1951, 2, the finds, part 1: amphorae, coarse pottery, building materials* by J. Dore and N. Keay (London 1989). Lamps should not be overlooked: see *A catalogue of the lamps in the British Museum 2: Roman lamps made in Italy* and *3: Roman provincial lamps* by D. M. Bailey (London 1980, 1988), and the same author's 'Lamps metal, lamps clay: a decade of publication' (*Journal of Roman Studies* 4, 1991, pp. 51–62). Architectural ceramics are

featured in *Roman brick and tile: studies in manufacture, distribution and use in the western empire*, edited by A. McWhirr (British Archaeological Reports S68, Oxford 1979).

Pottery production
Studies of production are very important. For general principles see O. S. Rye's *Pottery technology: principles and reconstruction* (Washington DC 1981); a good survey from a European perspective is *La ceramica in archeologia: antiche tecniche di lavorazione e moderni metodi di indagine* by N. Cuomo di Caprio (Rome 1985). Kilns have been published thoroughly by V. G. Swan, *The pottery kilns of Roman Britain* (London 1984) and F. Le Ny, *Les fours de tuiliers gallo-romains* (Paris 1988); good illustrations of excavation on a kiln site are included in *Sallèles-d'Aude: un complexe de potiers gallo-romain: le quartier artisanal* by F. Laubenheimer (Paris 1990). The important terra sigillata firing inscriptions from France have been collected in R. Marichal's *Les graffites de La Graufesenque* (Paris 1988). Some pottery industries which also produced lamps, tiles and moulded figurines are featured in various volumes of *Recherches sur les ateliers de potiers de la Gaule centrale* (in the series *Revue Archéologie Sites*) edited by H. Vertet, P. Bet and others throughout the 1980s.

Working with Roman pottery
General methods of studying pottery, including scientific techniques, are explained in P. M. Rice's *Pottery analysis: a sourcebook* (Chicago 1987); their application to the Roman period is reviewed in R. S. Tomber's 'Roman pottery studies in the Mediterranean: past research and future prospects' (*Journal of Roman Archaeology* 3, 1990, pp. 217–24). An important collection of studies, *Pottery and early commerce: characterization and trade in Roman and later ceramics* (London 1977) was edited by D. P. S. Peacock, and an interesting British Museum seminar was published in 1991 as *Recent developments in ceramic petrology*, edited by A. Middleton and I. Freestone; more general is *Datation-caractérisation des céramiques anciennes*, edited by T. Hackens and M. Schvoerer (Paris 1984). Many important aspects of working with site-finds are included in *Pottery and the archaeologist*, edited by M. Millett (London 1979); one specific study is my paper 'The Roman fortress at Usk, Wales, and the processing of Roman pottery for publication' (*Journal of Field Archaeology* 11, 1984, pp. 405–12). In the hope of standardising approaches, in 1986 the Rheinisches Landesmuseum in Bonn published *Suggestions for the systematic recording of pottery*, with parallel texts in German, English and French.

The economics of Roman pottery
Much has been written about the economic significance of Roman pottery; the general context is explored in my book *The archaeology of the Roman economy* (London 1986). General economic studies highlighting pottery include *Production and distribution: a ceramic viewpoint* edited by H. Howard and E. L. Morris (British Archaeological Reports S120, Oxford 1981). Amphorae and Red Slip Ware are prominent in C. Panella's 'La distribuzione e i mercati' in *Società romana e produzione schiavistica II: merci, mercati e scambi nel Mediterraneo*, edited by A. Giardina and A. Schiavone (Rome 1981), and A. Carandini's 'Pottery and the African economy' in *Trade in the ancient economy*, edited by P. Garnsey (London 1983). Literary sources, inscriptions and stamps form the basis of 'Roman terracotta lamps: the organization of an industry', by W. V. Harris (*Journal of Roman Studies* 70, 1980, pp. 126–45), T. Helen's *Organisation of Roman brick production in the first and second centuries AD* (Helsinki 1975), and G. Prachner's *Die Sklaven und Freigelassenen im arretinischen Sigillatagewerbe* (Wiesbaden 1980). The need for critical interpretation of maps of find-spots is stressed by A. Fitzpatrick in 'The distribution of Dressel 1 amphorae in north-west Europe' (*Oxford Journal of Archaeology* 4, 1985, pp. 305–40), but their potential when studied statistically is revealed by I. Hodder in 'Some marketing models for Romano-British coarse pottery' (*Britannia* 5, 1974, pp. 340–59).

Index